WESTERN ART OF THE TWENTY-FIRST CENTURY

NATIVE AMERICANS

E. ASHLEY ROONEY

Foreword by
SETH HOPKINS

Schiffer Publishing Ltd

4880 Lower Valley Road • Atglen, PA 19310

Designed by RoS
Cover design by Brenda McCallum
Type set in Mailart Rubberstamp/Chaparral Pro
Front Cover: M. C. Poulsen *Rainmaker*. *Ron Maier Photography*
Spine: Roy Andersen. *Quanah Parker*. *Marc Bennett, White Oak Studio*
Back Cover: John Coleman. *Unconquered*.

ISBN: 978-0-7643-5620-9
Printed in China

Published by Schiffer Publishing, Ltd.
4880 Lower Valley Road
Atglen, PA 19310
Phone: (610) 593-1777; Fax: (610) 593-2002
E-mail: Info@schifferbooks.com
Web: www.schifferbooks.com

For our complete selection of fine books on this and related subjects, please visit our website at www.schifferbooks.com. You may also write for a free catalog.

Schiffer Publishing's titles are available at special discounts for bulk purchases for sales promotions or premiums. Special editions, including personalized covers, corporate imprints, and excerpts, can be created in large quantities for special needs. For more information, contact the publisher.

We are always looking for people to write books on new and related subjects. If you have an idea for a book, please contact us at proposals@schifferbooks.com.

CONTENTS

Doug Hyde. *Nez Perce Family (Mother, Father, & Child)*.

PREFACE

Seth Hopkins' Pink Fuzzy Slippers Test

Stepping off the school bus in rural Maine and entering our small but cozy home, I had my pick of three fuzzy network television stations. My after-school viewing choices were the *Mike Douglas Show*, a soap opera, or the *Great Money Movie*. An easy choice. Sometime during the course of the movie, they would show the secret word of the day, and you could call in to win the big prize—$50. Most of the movies were a good twenty-five to thirty years old, including some fairly moldy westerns. I greatly favored the westerns, seeing a few of the classics and a lot of cheesy ones. They instilled an interest in cowboys and Indians in me, in much the same way the great western-art collectors among my elders gained their affection/ affliction through vicarious western travels with Gene Autry and Roy Rogers.

This interest would lay dormant during my early adult life, until I found myself working for one of those great collectors whose love for Gene and Roy manifested itself in one of the great contemporary western-art collections. On the walls of the business were paintings of scenes I had encountered on many weekday afternoons, and sculptures that brought to life the stories I knew only from film. Ten years after I went to work there, the boss man walked in and said, "We are going to sell this company, build a western-art museum, and I want you to run it." I protested, saying I did not know anything about art or museums. He assured me it would be fine. The three years that it would take to build the building would give me time to learn what I could about art. Thus began my crash course in western history and western art.

Despite having a minor in American history from a major eastern university, I was amazed how very little I knew about anything that ever happened west of the Mississippi. Even that dividing line, so universally used by easterners to define the West, was a lie; Louisiana and Arkansas, both west of the Mississippi, are hardly the West. I would learn that the hundredth meridian was a much more usable divisor of where the West begins. Of course, time as much as place can define what constitutes the West in western art. Quite often the word "frontier" serves as a better descriptor. After taking classes at a half-dozen institutions, I eventually earned a master's degree from the University of Oklahoma, the only school in the country now offering a doctorate in western art.

When the Booth Western Art Museum opened in 2003, I felt at least conversant in the basics of western art. It remains an educational, fun, challenging, and rewarding pursuit. When I was tempted to decline my first invitation to judge a major art show, my mentor reminded me I was looking at more western art on a regular basis than almost anybody else. Trusting my training, networking, and developing eye, I have endeavored to establish the Booth as the leader in exhibiting, collecting, and promoting the work of living western artists. We have also tried to increase the interest in western art throughout the Southeast, encouraging new collectors, connecting existing collectors, and working with partners that share our goals.

One of the things that struck me in the early days of my journey to art enlightenment was that it seemed somewhat silly to have art competitions, give awards, and try to establish a clear pecking order among artists. Visual art generates such a personal and emotional response that varies greatly from person to person that it seemed to me quite difficult to label

artists as the "winner," "best," or "master." But as I compared visual arts to performing arts such as music, film, and the theater, it was clear there are many measures by which performers or projects are rated. Whether these measures are awards such as the Oscars or the Grammys, sales figures, or box office numbers, winners and losers definitely exist.

My artist friend Mort Kunstler once told me, "In the visual arts we don't have applause like they do in performing arts; however, the dollars are the applause." So I began to realize that competition, awards, and the tracking of sales data in the visual arts are helpful in creating buzz and getting people talking about art. The more collectors debate who is the best, who does certain subjects better, or who is leading the field stylistically into new areas, the more engaged they become, which helps all concerned.

Although much of the art market buzz surrounds money, I urge collectors not to get caught up in trying to make money on their art. The system has too-many built-in costs, and picking a winner is a crapshoot at best. When people ask whom they should invest in, my standard response is that if I knew that, I would be mortgaging my house. Instead, I urge them to employ "Seth Hopkins' Pink Fuzzy Slippers Test," whereby you access your art purchases on Sunday mornings, coffee and paper in hand and pink slippers employed. Works that elicit a slow, silly grin to form—because you are the current steward of a work of art you love living with—pass the test.

Against this backdrop, I received a call from Ashley Rooney one day, saying that she had been referred to me by someone I respect in the field. They had told her I was the one who could best help her with a new project. The premise was to identify the top forty living artists doing cowboys and the top forty artists doing Native Americans, to be profiled in a two-book set.

I immediately had flashbacks to one of my other favorite programs among our quite limited entertainment options, the *American Country Countdown* with Bob Kingsley. Every weekend he counted down the top-forty country-western hits on the basis of airplay, as reported by *Billboard* magazine. With no Internet to look up the results, nor any other source of information, we had no choice but to listen along and discover who was number one each week.

When I asked what criteria should be applied and who was already on the list, she said it was up to me. So here I was, given the chance to be *Billboard* magazine and select the top forty—although in this case it was limited to thirty—and I was saved the arduous task of ranking them. Establishing my own criteria, I began with the obvious—sometimes hard to find, and harder to define—quality. Eventually, I found myself agreeing with the Supreme Court justice who said he could not define pornography, but he knew it when he saw it. I know high quality when I encounter it.

Beyond high quality, I wanted to add some diversity of subjects, styles, and artists' backgrounds, including a broad range of geography, ethnicity, and gender, because these attributes help create the diverse collection of images we foresaw for this book. We hoped to provide something of visual interest for the reader/viewer, rather than a monotony of cowboy going right and cowboy going left.

Certainly, the core of the book, and still the core of the contemporary western-art field, are the fairly traditional images descended from George Catlin, Karl Bodmer, Frederic Remington, and Charlie Russell. Many other great artists may have more in common with modern-leaning regionalists, pop artists, or even the abstractionists of an earlier generation. Currently, traditional works still generally bring the higher prices in the market, and if dollars equal applause, then applause equals attention, but do not forget Seth Hopkins' Pink Fuzzy Slippers Test!

Risking friendships and possibly creating enemies, I think the artists herein are the best. The resulting debate, done in a healthy and good-natured way, is positive fodder for the gristmill and in the long run is healthy in keeping western art alive and well.

INTRODUCTION

On the Range

When Schiffer Publishing suggested that I compile a book on contemporary Wild West artists , I quickly realized what an enormous and potentially daunting project I had undertaken. I needed an expert, and I found one in Seth Hopkins, executive director of the Booth Western Art Museum in Cartersville, Georgia, a position he has held since 2000. *Southwest Art Magazine* included Hopkins on its list of ten prominent people who are "making noteworthy contributions to the art world."

Seth Hopkins knew who should be in the book, and together with Schiffer Publishing, we decided that it should be two books: *Western Art of the Twenty-First Century: Cowboys* and *Western Art of the Twenty-First Century: Native Americans*.

> I have heard you intend to settle us on a reservation near the mountains. I don't want to settle. I love to roam over the prairies. There I feel free and happy, but when we settle down we grow pale and die.
>
> –Chief Satanta of the Kiowa Tribe at Fort Larned.

Many people think that the development of the western United States, especially in the second half of the nineteenth century, is a story full of glory and romance, often supported by reportage of the day along with art, literature, and music. Hindsight shows that the romance was often exaggerated. Instead, as Robert Hine and John Faragher point out, "It is a tale of conquest, but also one of survival, persistence, and the merging of peoples and cultures that gave birth and continuing life to America."[1]

Archaeological evidence shows that indigenous peoples lived throughout the West for thousands of years. Most natives on the plains were nomadic, following the buffalo herds and other game. Thousands of Native Americans lived in present-day Texas for many generations. Hunters and healers, traders and artisans, they had developed ways of life that worked for them; the differences in languages, beliefs, and everyday customs made many interactions between them and the Spanish almost impossible. The Native Americans resented the priests and military, died from their diseases, and were enslaved or killed by them. Aggressively defending their territory, the tribes would raid livestock herds, kill soldiers, and burn settlers' homes.

After the United States acquired a large part of the West through the Louisiana Purchase of 1803, American explorers such as Lewis and Clark, Zebulon M. Pike, and John C. Fremont began to reconnoiter this vast region. They returned from their wilderness expeditions with varying stories, ranging from reports of great stretches of beauty and fertile land to desert wasteland. Soon, trappers, prospectors, ranchers, and farmers moved into the region.

When Mexico finally gained its independence from the Spaniards in 1821, Texas became part of Mexico. The Mexican government tried to better its economy by encouraging immigration from the United States, offering grants to men to establish colonies. One of the first of these impresarios was Stephen F. Austin, now known as the "Father of Texas." Attracted by the chance for a better life and more land, settlers from Tennessee, Kentucky, Arkansas, Georgia, the Carolinas, Alabama, Missouri, and elsewhere moved to the territory. By 1835, ten times as many Texan Anglos—who were often slave

owners—as Mexicans lived in the region. Life on the vast Texas frontier was hard. Bandits and Native Americans often attacked settlers living on small ranches and farms. Governor Austin created the first Texas Ranger company to defend the settlers.

By 1847, Brigham Young and several thousand pioneering Mormons began building the future Salt Lake City at the foot of the Wasatch Mountains. Early gold strikes at Sutter's Mill in 1848 led to waves of "49'ers" flocking to California. Later discoveries in the Pike's Peak area in 1858, Last Chance Gulch in Helena, Montana, and Clearwater River in Idaho were a major catalyst for westward migration. During the early 1860s, thousands of gold seekers flocked to the region, working their way up the canyons and hoping to find their fortunes. Although the easily accessible gold deposits along the rivers and streams were rapidly depleted, the prospectors soon discovered gold, silver, and other minerals within the nearby mountains. Getting to them would prove more difficult and damaging to the land.

After the first transcontinental railroad was completed in 1869, immigrants began using the train system to migrate west and form even more settlements in the region. In 1872, under the Pacific Railroad Act, Congress awarded the railroads over 170 million acres in land grants. Seizing upon this opportunity, the railroads sent agents to the East and to Europe to attract potential settlers to these western lands of limitless opportunity. From 1860 to 1900, more than twelve million Europeans entered the United States. Many settled east of the Mississippi; many others, lured by the opportunity of a new life in the "wide open spaces," moved west.

As more settlers and immigrants moved into the region, conflicts with Native Americans increased. The Native Americans had lived for centuries by following the buffalo herds and other game. Throughout the region, settlers killed the wildlife, felled forests and woodlands, and dammed rivers. They plowed up the prairie, killed the buffalo, and overgrazed their sheep. Utah's expanding Mormon settlement drove the natives from the valleys where they had lived for centuries, and the Mormon cattle consumed native grasses and other plants.

Many tribes—from the Utes of the Great Basin to the Nez Perce of Idaho—fought the intruders. The Sioux of the northern Plains were famous for their resistance to settlers invading their tribal lands. In 1875, the last major Sioux war erupted when the Dakota gold rush penetrated the Black Hills. At the Battle of the Little Bighorn in 1876, 263 US Army soldiers, including Lt. Col. George A. Custer, died fighting several thousand Lakota and Cheyenne warriors. Although the natives were victorious, their way of life was doomed. Without the buffalo, the Native Americans were forced to depend on the US government for food. Defeated and demoralized, the Native Americans were placed or confined on government reservations.

The exploration, settlement, exploitation, and conflicts of the West have been memorialized by many. Artists such as Frederic Remington, Charles M. Russell, and others portrayed often-mythic western tales through their work. In conjunction with the other book in this series, *Western Art of the Twenty-First Century: Cowboys*, this volume invites readers to reexamine the history of the West and its art through a multi-faceted modern lens. The thirty-one artists represented in this book reflect the tremendous diversity, depth, and breadth of a field steeped in history. Many follow the traditions established by Remington and Russell; others seek to break from tradition, busting myths and bringing new insights and artistic styles to the genre. They come from both sides of the Mississippi and have pedigrees that range from bona fide cowboy or Indian credentials to careers in commercial illustration. The unifying theme is a common concern for and commitment to their art and the West itself.

[1]Hine, Robert, and John Faragher. *The American West: A New Frontier*. New Haven, CT: Yale University Press, 2000.

McPherson, James M. *Into the West: From Reconstruction to the Final Days of the American Frontier*. New York: Atheneum Books for Young Readers, 2006.

THE
ARTISTS

TONY ABEYTA

Santa Fe, New Mexico, and Berkeley, California

My primary focus has been on painting the emotional experience one finds in the New Mexico landscape. There exists a rhythm in the land where I was born. I spend a lot of time deciphering the light; the cascades of mesas into canyons, the marriage between earth and sky and the light as it constantly changes on a whim, the intensity of rock formations, and the sage and chamisa that accent this poetic experience, unlike anywhere else I have seen. I am beckoned to remember it and then to paint it.

I am a Navajo contemporary artist working in mixed-media paintings. I graduated from New York University and hold an honorary doctorate from the Institute of American Indian Arts in Santa Fe. I was the 2012 recipient of the New Mexico Governor's Excellence in the Arts award and have been recognized as a native treasure by the Museum of Indian Arts & Culture.

All images courtesy of the Owings Gallery, Santa Fe, New Mexico

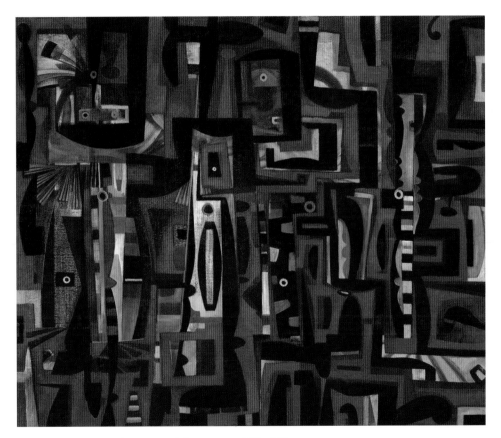

The Corner of Pico and Pojoaque. Oil on canvas. 50" × 60".

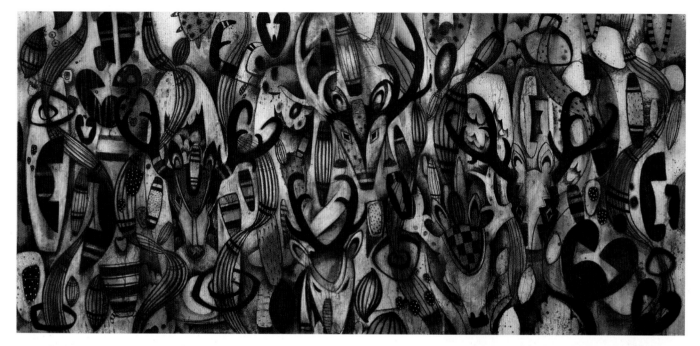

Deer Rhythms. Charcoal and ink wash on paper mounted on canvas.
34" × 72".

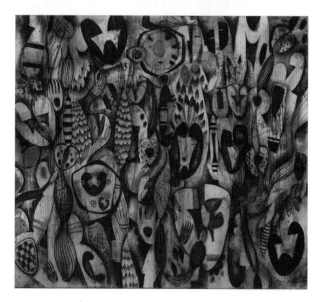

From Darkness There Was Song. Charcoal and ink
wash on paper mounted on canvas. 70" × 72".

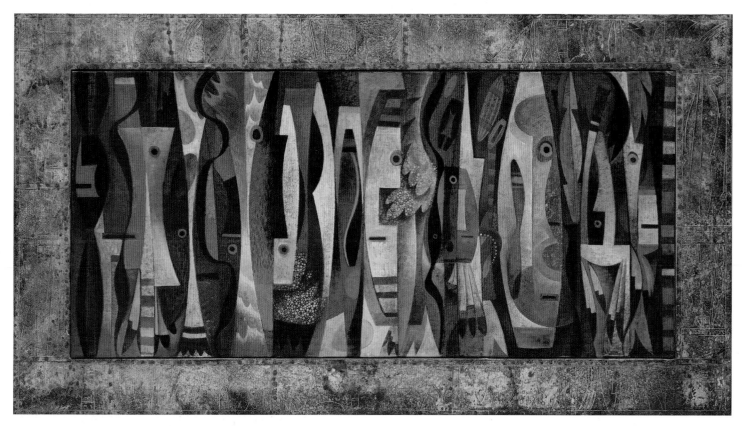

Modernist Mask Composition. Oil on canvas. 36" × 57".

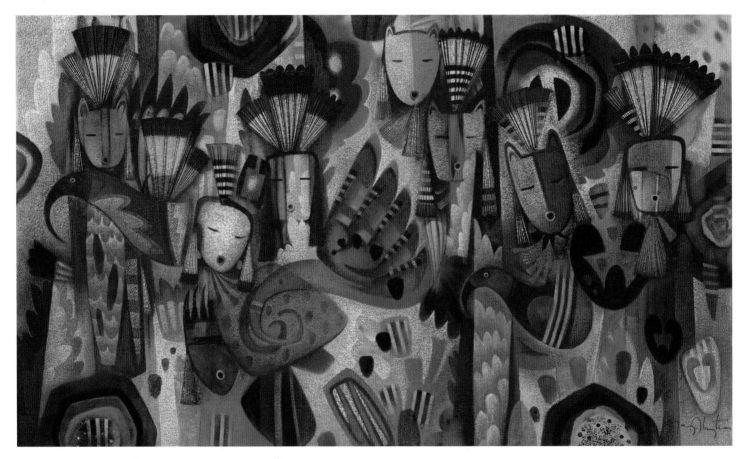

Welcoming the Eagles. Oil on canvas with sand. 42" × 72".

WILLIAM ACHEFF

TAOS, NEW MEXICO

My original goal in painting was to try to paint objects so they appeared real. As I matured and discovered the Native American subject in 1974, I realized that I could tell a story with the objects by incorporating an old photo. Realism and the perception of depth are primary concerns only fully achieved by painting from life. That, of course, is what I paint from.

Warrior to Welfare. 26" × 34".

Hunting Lesson. 22" × 28".

Tranquil Yellow Light. 12" × 19".

Children Were in the Orchard. 10" × 20".

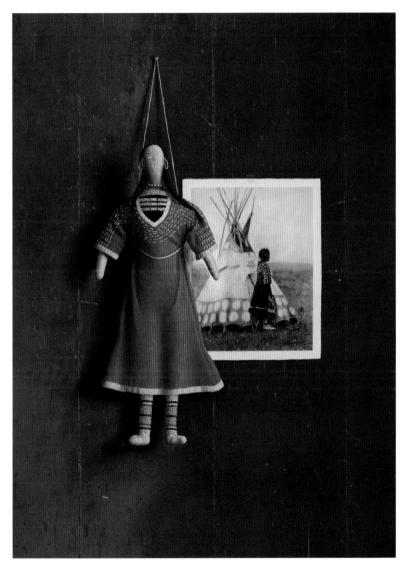

Doll in the Red Dress. 30" × 22".

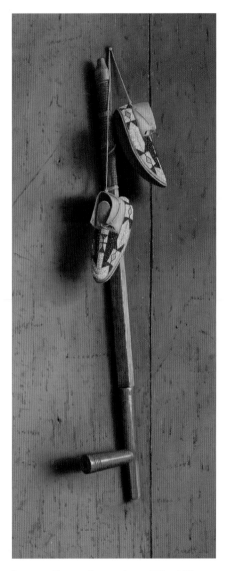

Peace to Future Generations. 25" × 10".

ROY ANDERSEN

KERRVILLE, TEXAS

Western art started for me as a way of illustrating an unwritten text. Stories ran sideways through my brain, equal parts movie, comic strip, and cowboy paperback, with a strong dash of historical research thrown in. The Indians, cowboys, and settlers who yesterday moved through this land are gone, but the space itself is still there. Like all life, it changes yet remains the same.

Indians believe life moves in circles. I returned to a love of horses and the native people who lived their lives on horseback. Indians and western art are my primary focus, not just because Indians are picturesque, but also because they are living symbols who express the thoughts of free men and animals through a natural world. They are real, spiritual, serious, and honest people looking for a connection between God and their own nature and the beautiful landscape around them.

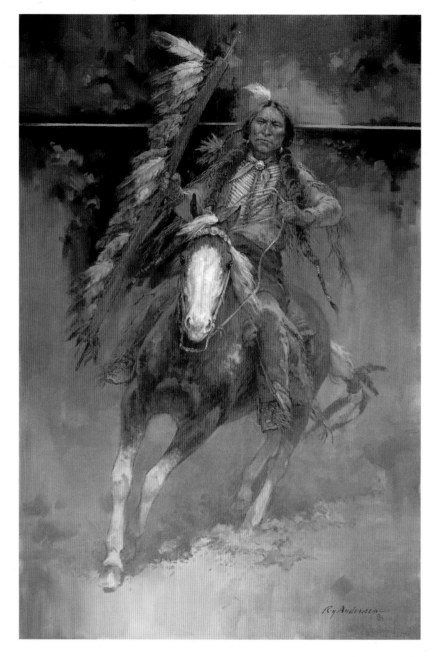

Quanah Parker. 48" × 32". 2010.
Photo courtesy of Marc Bennett, White Oak Studio

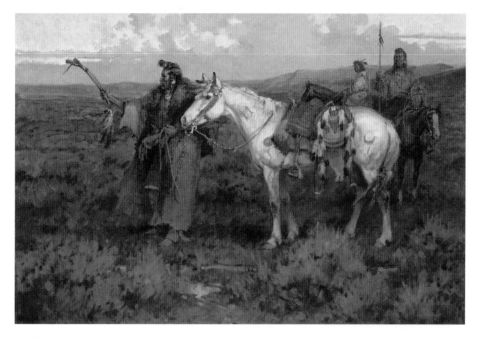

The Medicine Pony. 24" × 36". 2011.
Photo courtesy of Marc Bennett, White Oak Studio

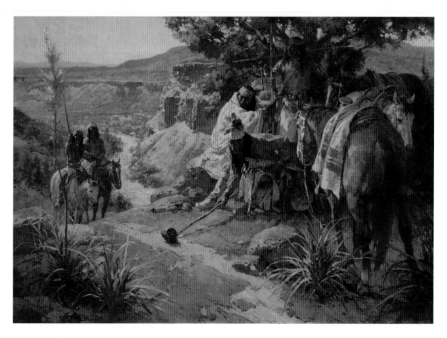

The Pindah War Cap. 49" × 63". 1999.
Courtesy of Booth Museum

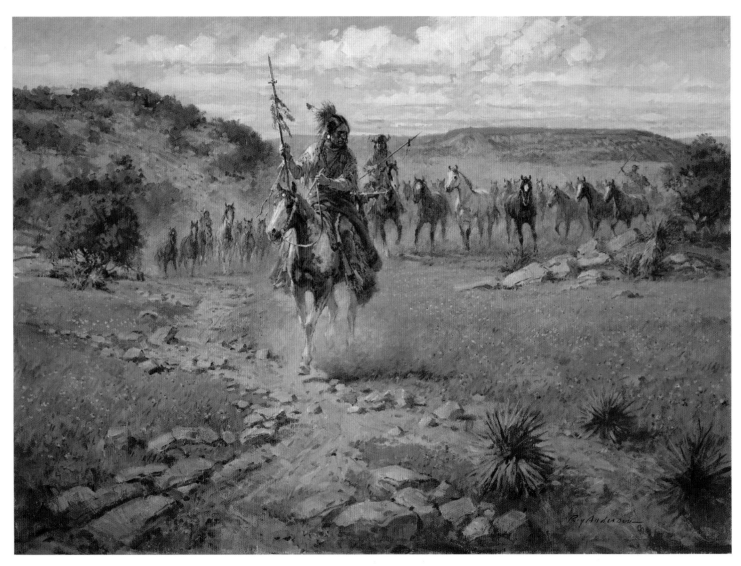

Comanche Spring. 26" × 36". 2012. *Photo courtesy of Marc Bennett, White Oak Studio*

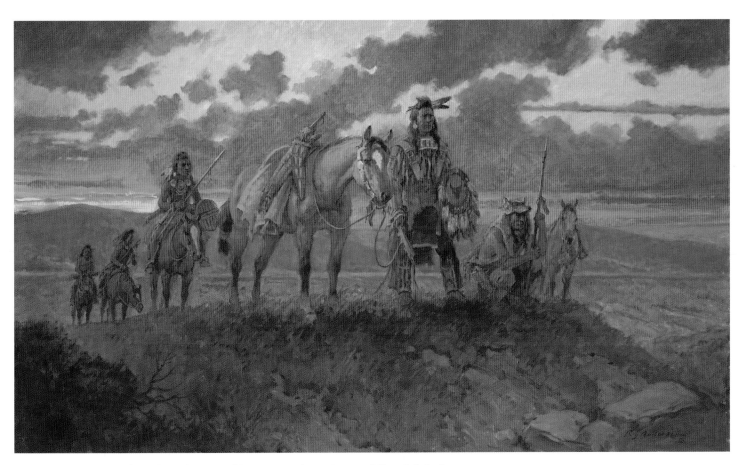

The Trail of Distant Smoke. 30" × 50". 2014. *Photo courtesy of Marc Bennett, White Oak Studio*

JAMES AYERS

SCOTTSDALE, ARIZONA

My paintings are more than just a slice of Native American history. They are the result of years of research, combined with personal exploration and observation. I study historic artifacts, research customs and rituals, and marry these with my understanding of the struggles of modern Native American cultures. In the face of inevitable change, my mission is to honor the customs and beauty of traditional cultures through my paintings.

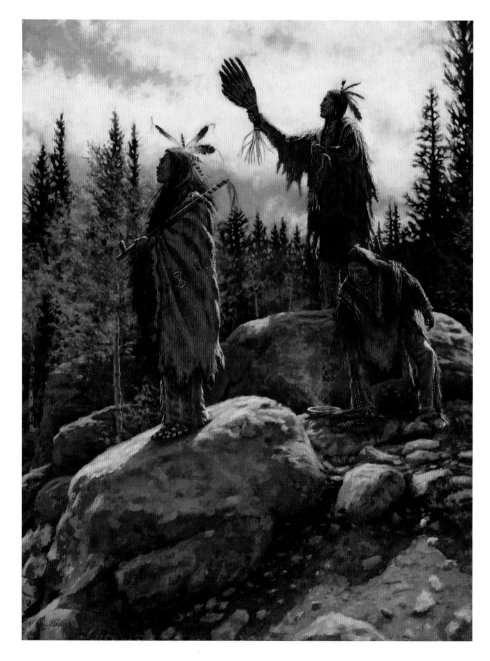

Oglala Offerings. Oil on canvas. 48" × 36". 2014.

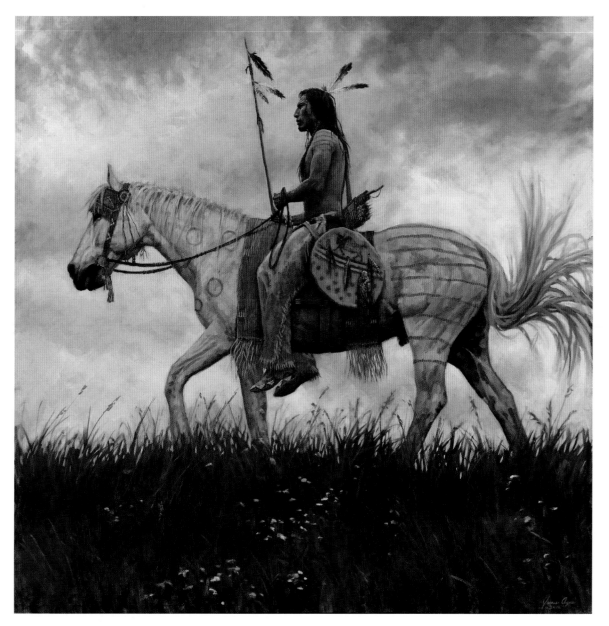

Lakota Horseman. Oil on canvas. 48" × 48". 2016.

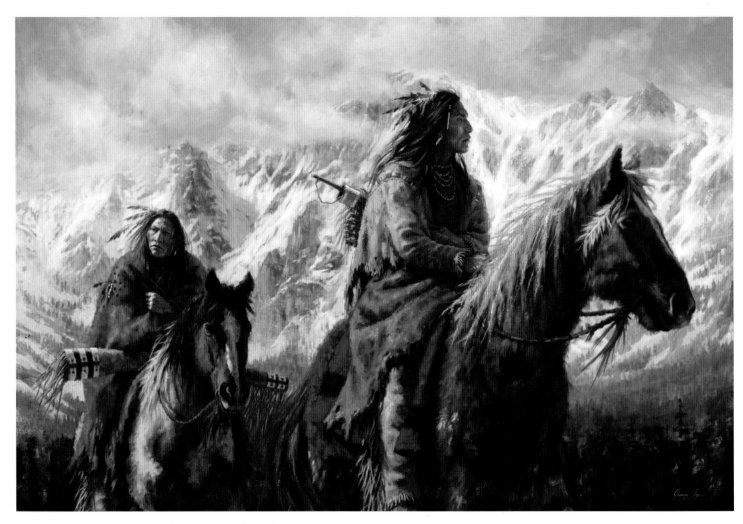

Warriors of the High Country. Oil on canvas. 40" × 60". 2008.

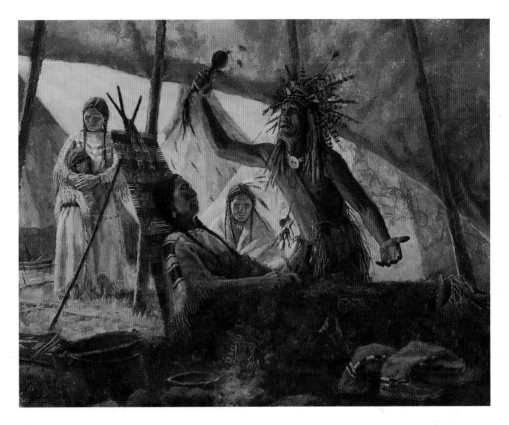

Prayers of the Shaman. Oil on canvas. 24" × 30". 2014.

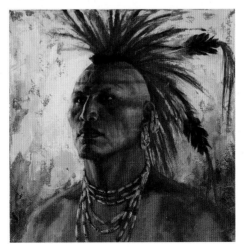

Pawnee Strength. Oil on canvas. 16" × 16". 2016.

SHONTO BEGAY

FLAGSTAFF, ARIZONA

My mother is a traditional Navajo rug weaver from the Bitter Water Clan, and my father is a medicine man born to the Salt Clan. I was born in a hogan and raised on Dineh land, which is known as the Navajo Nation. I grew up herding sheep in Kletha Valley, in Shonto, Arizona.

I began professionally writing, illustrating, and painting in 1983. My acrylic paintings are done in a series of small brushstrokes that repeat like the words of a traditional Navajo blessing prayer.

The Pink Letter. Acrylic on canvas. 36" × 24". 1999. *Courtesy of Tom Alexander*

Witness. Acrylic on canvas. 45" × 84". 2000. *Courtesy of Tom Alexander*

Gift of the Passing Storm. Acrylic on canvas. 12" × 24". 2016. *Courtesy of Tom Alexander*

Our Promised Road. Acrylic on canvas. 43" × 72". 2007. *Courtesy of Booth Museum*

Citation on the Green. Acrylic on canvas. 58" × 76". 1999. *Courtesy of Tom Alexander*

HARLEY BROWN

TUCSON, ARIZONA

I have been interested in the West, especially the frontier West, since childhood. In my youth, in Alberta, Canada, I was fortunate to live within blocks of First Nation people of Sarcee, Blackfoot, and Peigan descent. My art eventually extended to the native peoples of the northern American states. It has been an inspiring world for me portraying their unique and grand individualities from my teen years onward. Over half a century!

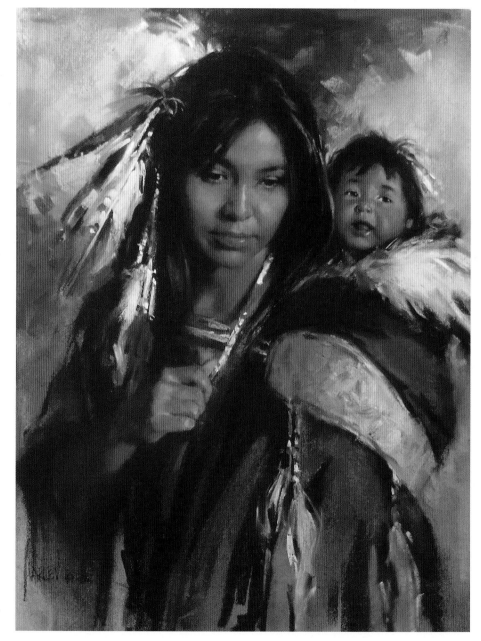

Mother Love. Pastel. 21" × 17".

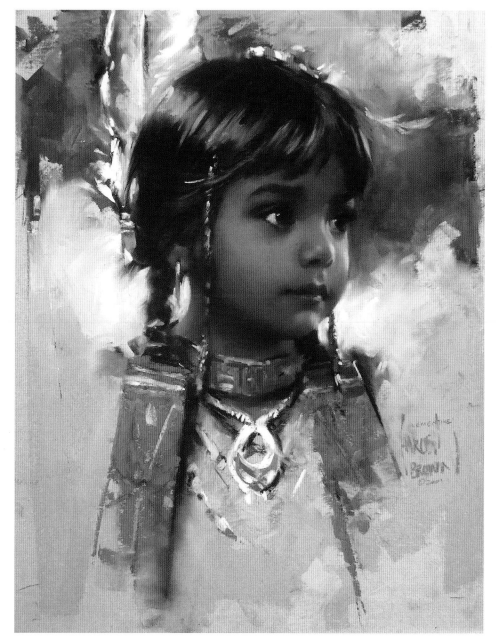

Young Dancer. Pastel. 12" × 9".

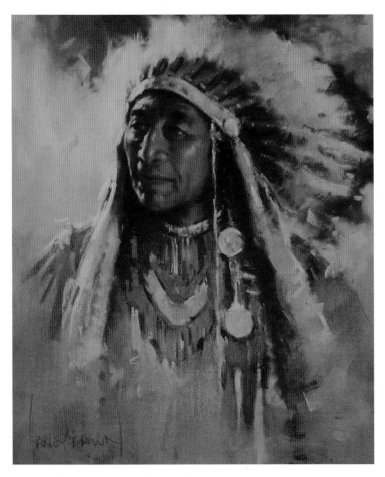

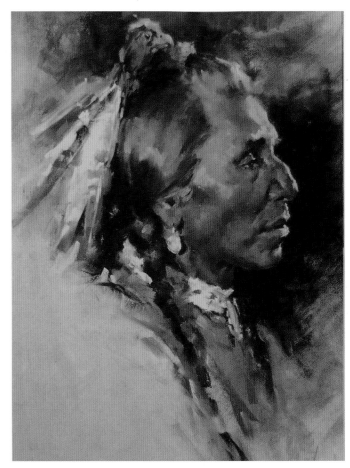

Plains Elder. Pastel. 18" × 20".

Lands of Legends. Pastel. 18" × 14".

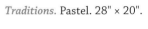

Traditions. Pastel. 28" × 20".

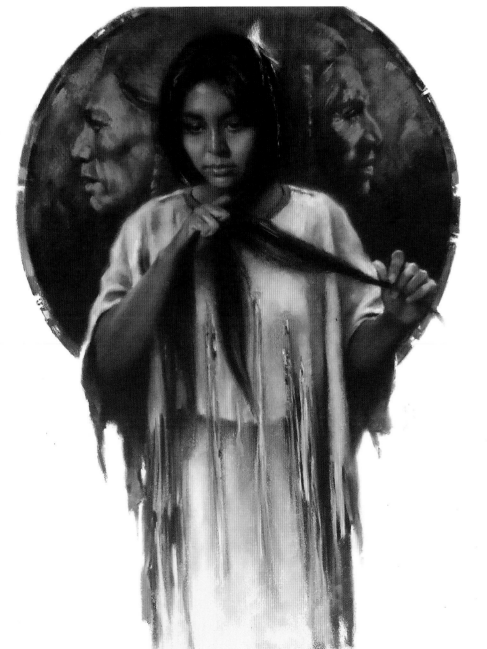

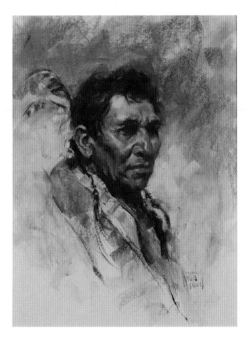

Old Weasel. Pastel. 24" × 18".
Courtesy of Booth Museum

BLAIR BUSWELL

PLEASANT GROVE, UTAH

I have always been fascinated with the human figure. I like the challenge of capturing the gesture, mood, and expression of my subject. I have learned that all great art starts with a strong composition that leads the viewer's eye through the abstract shapes, keeping them engaged. I try to combine all of these elements together to bring a sense of life to my work.

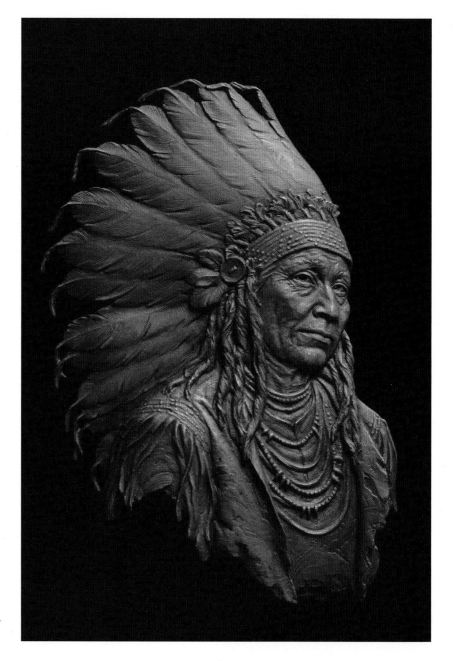

Undaunted. 18" × 12".

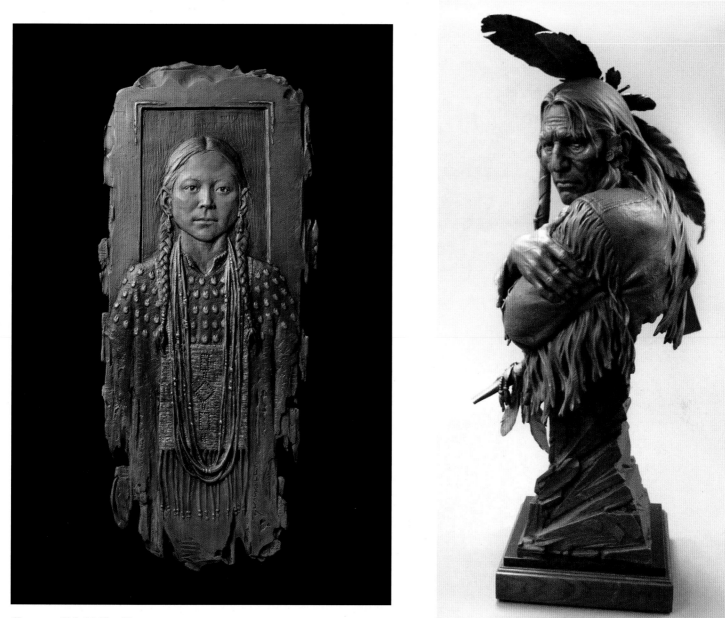

Cheyenne Girl. 19.5" × 9".

How Many More. Bronze. 48" × 22" × 24".

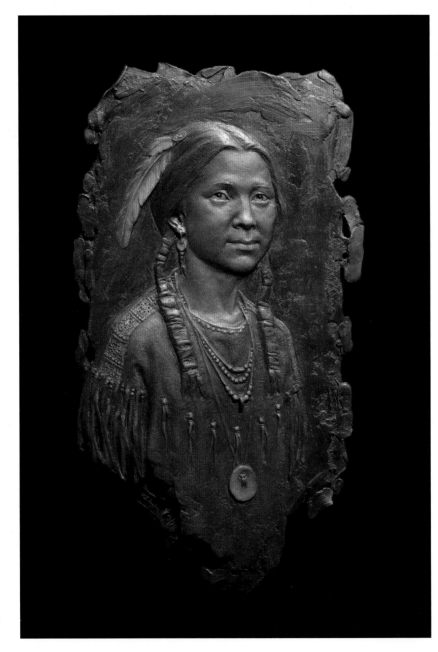

Prairie Princess. 16" × 9".

GEORGE CARLSON

HARRISON, IDAHO

I have been an artist for more than fifty years. I started out to be a painter and then became interested in sculpture to understand volume and forms. When I lived in Taos, I became interested in the Pueblo Indian culture, which eventually led to my interest in the Tarahumara Indians of Mexico.

Along the way, I had a one-man show at the Smithsonian's National Museum of Natural History and won the prestigious Prix de West for my sculpture *Courtship Flight* in 1975, and again in 2011, for a painting, *Umatilla Rock*. I have a strong belief in the mystical qualities of life . . . there are a lot of things that escape explanation. Those are the realms where my artistic explorations take me.

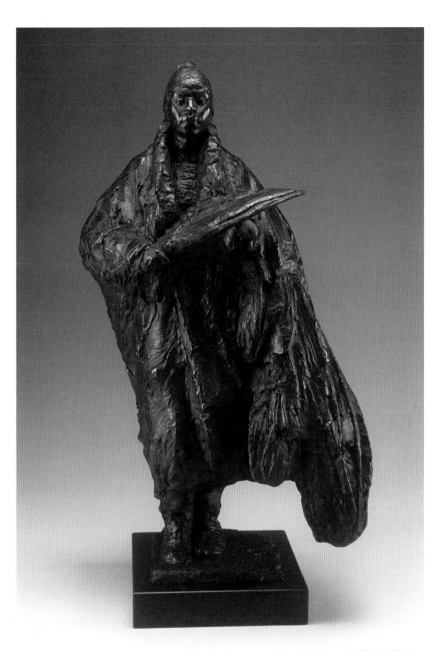

The Graceful Dance. Bronze. 31" × 16" × 15". 2002.

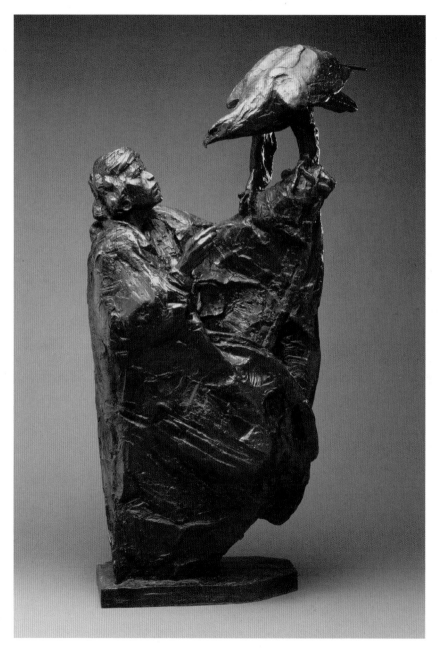

Boy & the Eagle II. Bronze. 52". 1989.

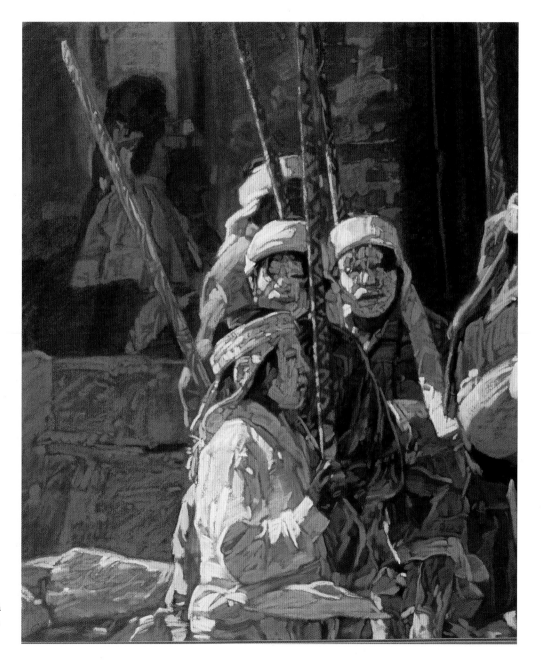

Children of the Sword. Pastel on Canson paper. 24" × 21". 1985.

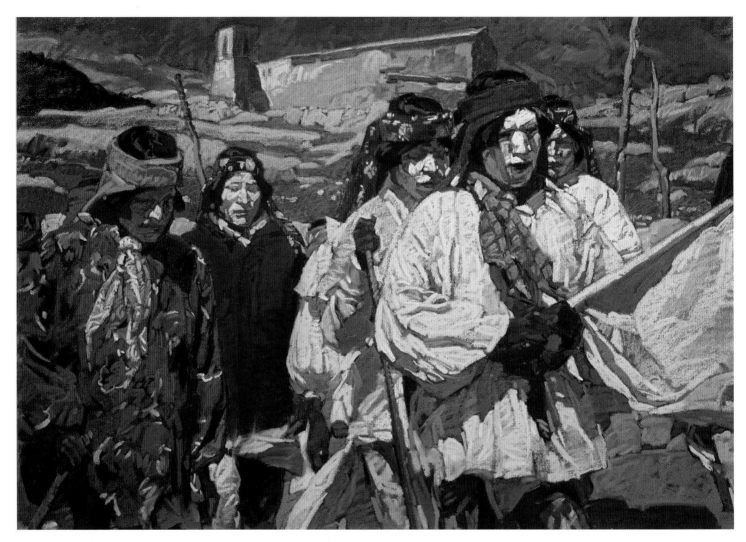

Clay Faces. Pastel on Canson paper . 19.5" × 28". 1984.

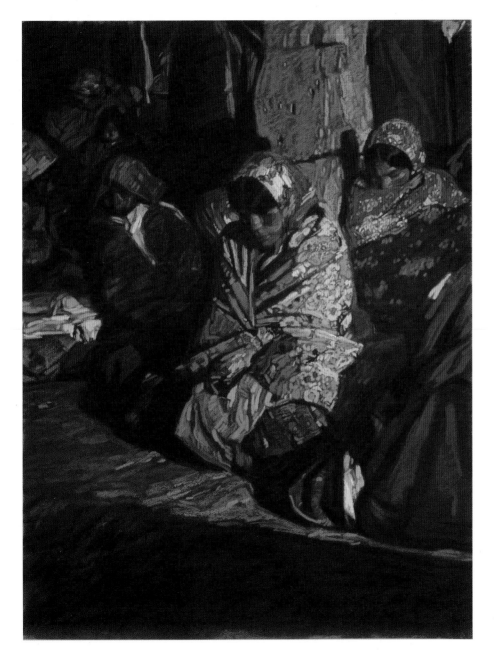

In Silence. Pastel on Canson paper .
28" × 19". 1986.

JOHN COLEMAN, FNSS, CAA, CAC

PRESCOTT, ARIZONA

I started my artistic career in earnest at forty-three, but I had previously spent twenty years developing a spiritual reverence for the act of creating art. My first ambition was to become what I reckoned was a true artist. A true artist in my opinion is one who chooses a vocabulary to communicate ethereal ideas. It is said that a poet concerns himself less with words and more with the spaces between them. As a visual artist, my life's goal is to be measured in the same ethereal way. Using form as opposed to words or musical notes to articulate deep ideas and emotions and expecting them to be understood is very challenging. The main point is that art is not created until the artist has something to say. I consider myself a history artist, but my main interest is in the metaphors history creates. As an example, a modern man wearing a business suit does not have the same impact as creating a metaphor using a Sioux chief in his seventies wearing a full eagle headdress and peace medal, although both portray powerful images of men who have lived well and have the respect of their people.

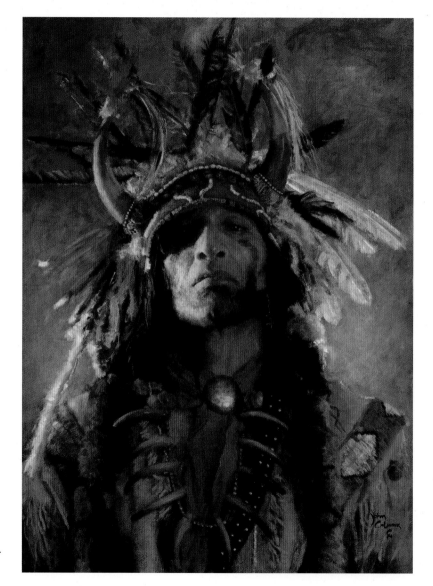

Holy Man of the Buffalo Nation. Oil on canvas. 23" × 16.5". 2012.

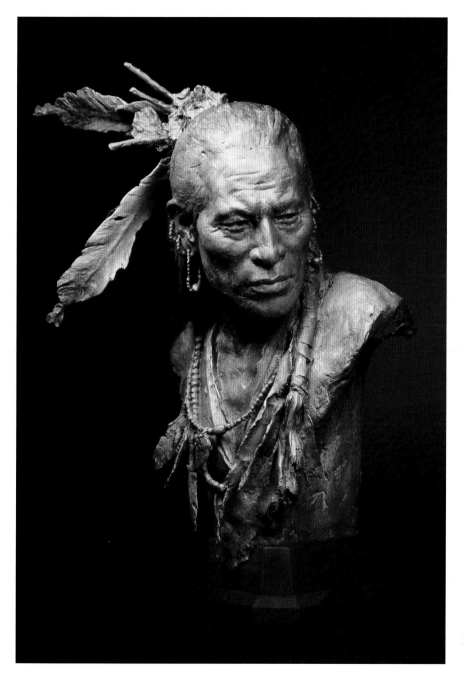

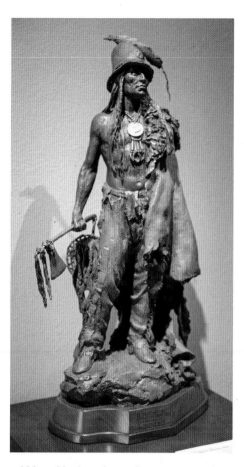

Addih-Hiddisch, Hidatsa Chief. Bronze. 34" × 17" × 11". 2004. *Courtesy of Booth Museum*

1832, Arikara Chief. Bronze. 24" × 18" × 13". 2015.

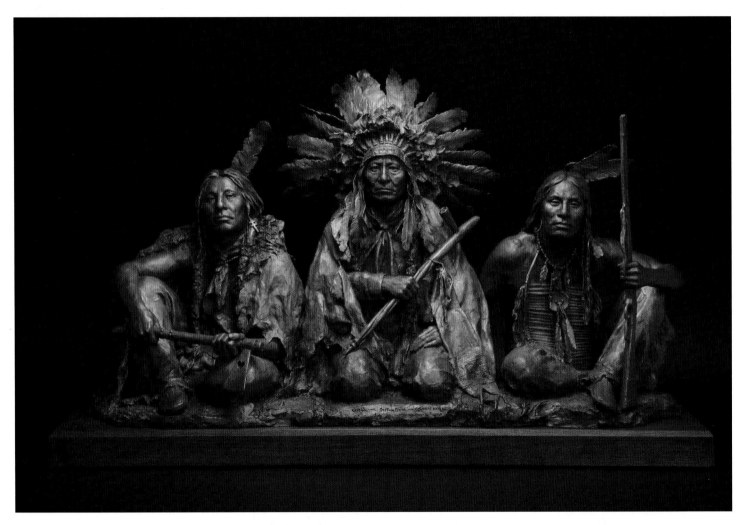

1876, Gall—Sitting Bull—Crazy Horse. Bronze. 33" × 59" × 22". 2008.

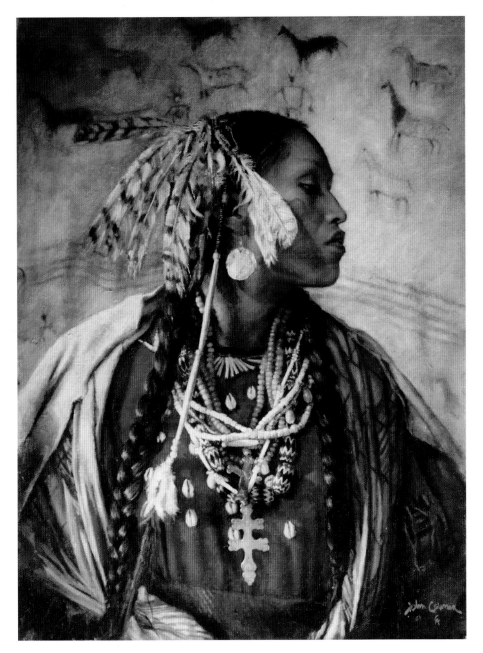

Unconquered. Oil on canvas. 24"x 18". 2014.

ALLEN AND PATTY ECKMAN

In 1987, after twelve years in commercial art, my wife, Patty, and I decided to move into the fine-art arena. We thought we were going to paint, but while creating my last client's brochure, I visualized the cast-paper medium for the first time. In my mind's eye, I saw what we are creating now but knew nothing about the medium. I did know my subject however. I wanted to do a fine-art study of the North American Indian.

The detail in the subjects I wanted to create forced me to move far beyond the medium of cast paper. Our medium evolved over the first five years from cast paper to cast-paper sculpture; now we can create infinite detail.

We start with acid-free fibers from which we formulate our own paper pulp. From the pulp, we make paper sheets, hard and soft, thick and thin. We sculpt with an acid-free hardener or bonding agent, giving the finished product a similar hardness to wood and leather. We have also developed a revolutionary process that allows us to turn our paper creations into bronze while retaining the archival paper in its original state.

ALLEN ECKMAN

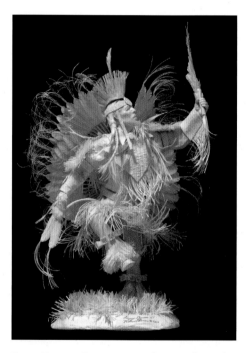

Traditional Dancer. Cast-paper sculpture (freestanding). 24" × 16" × 16". 2008.

Fancy Dancer. Cast-paper sculpture. 5' × 4.5' × 4.5'. 2011.

PATTY ECKMAN

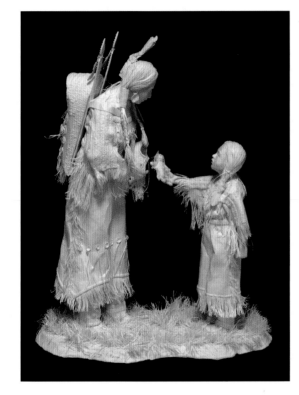

A Mother's Legacy. Cast-paper sculpture. 25" × 23" ×
14.5". *Courtesy of Booth Museum*

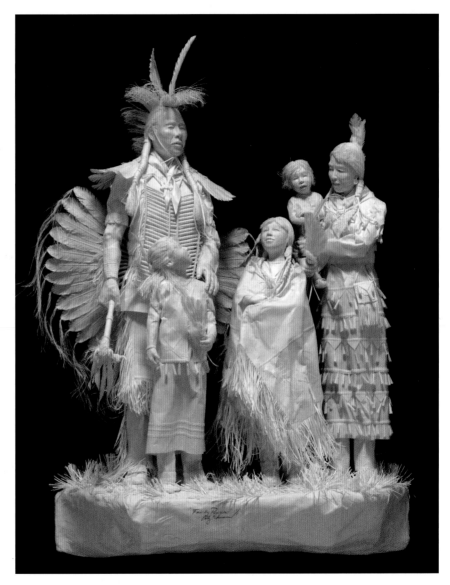

Powwow. 36" × 30" × 10". 2009.

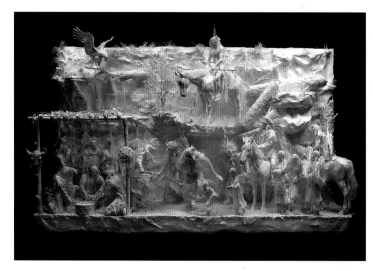

Prairie Edge Powwow.
Paper. 80" × 90" ×
22". 2001. *Courtesy
of Booth Museum*

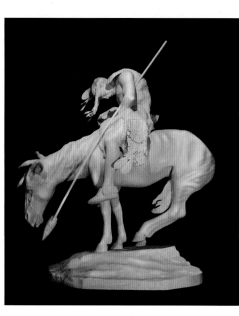

*End of the Trail after
James Earle Fraser.*
Original sealed-paper
sculpture. 20' × 12' ×
16'. 2015.

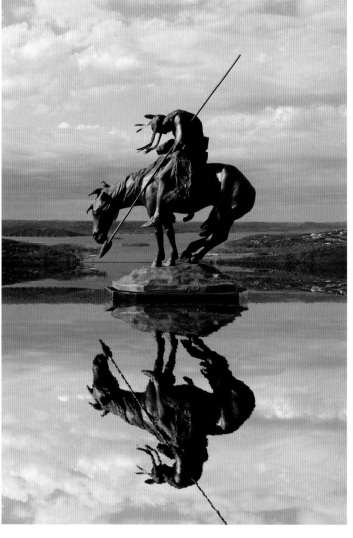

End of the Trail after James Earle Fraser. Bronze. 20' × 12' × 16'. 2015.

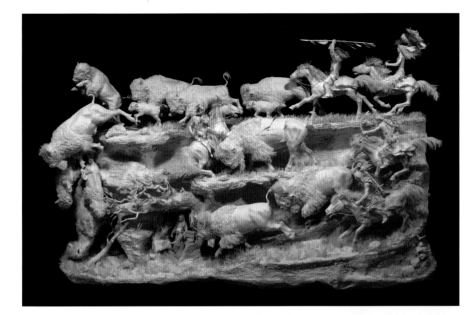

Prairie Edge Hunt. Cast-paper sculpture. 5' × 7.5' × 18". 2008.

John Norton. Original sealed-paper sculpture. 9.5' × 42" × 42". 2016.

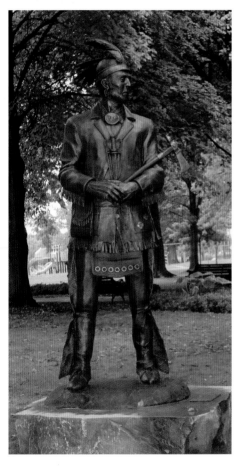

John Brant. Bronze. 10' × 42" × 42". 2016.

ETHELINDA

SANTE FE, NEW MEXICO

Paintings exist everywhere in nature. Whenever I see one, I am usually so thrilled I want to scale the subject large so the viewer can really see how beautiful and fascinating it is. To me, the impact of a canvas has to do with exciting broad strokes foiled by intricate detail rendered in the high relief that oil paint makes possible. I try to paint things as they have not been seen before— impromptu, perhaps with some aspect of humor. Whether it is a French scene or a pomegranate, the subject is real, completely absorbing, and demanding. Whatever it takes, I want the viewer to see what I see.

Out west in 1988, I discovered Indians. Their clothing seemed to be inspired by birds. I am most grateful to Rosemary and (the late) T. Dennis Lessard for authenticating every detail of dress in my paintings. These Indian paintings are my effort to preserve an era that no longer exists.

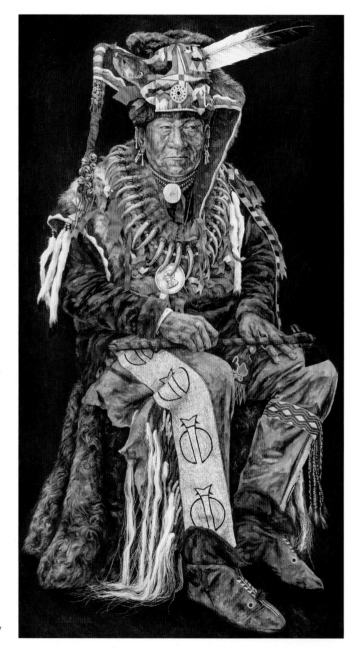

Little Dog - Blackfoot. 60" × 46". 1998.
All photography by John Guernsey Photography

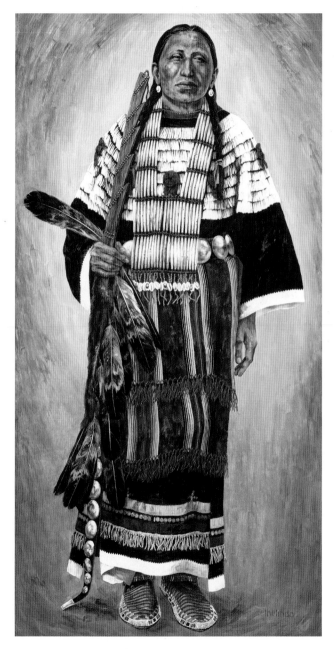

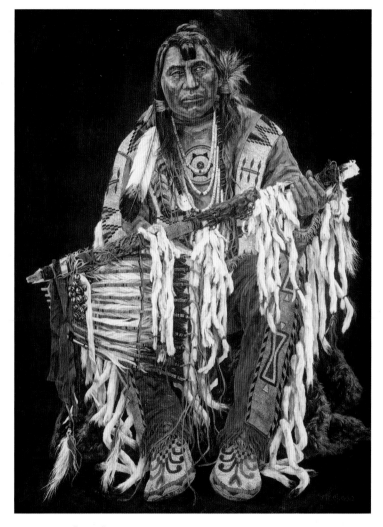

The Iowa. 60" × 46".

Jicarilla—Apache. 72" × 52". 2000.

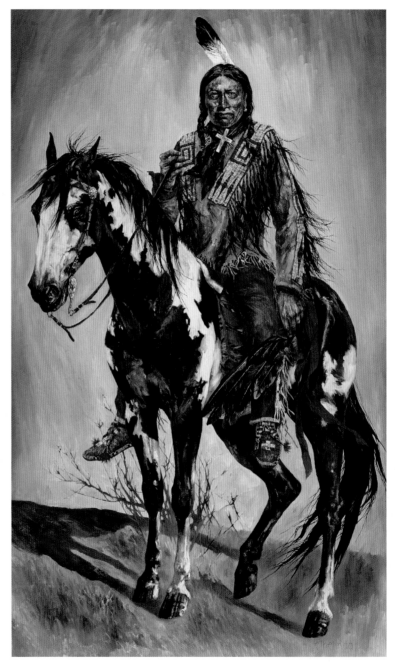

High Hawk—Sioux. 72" × 52". 2003.

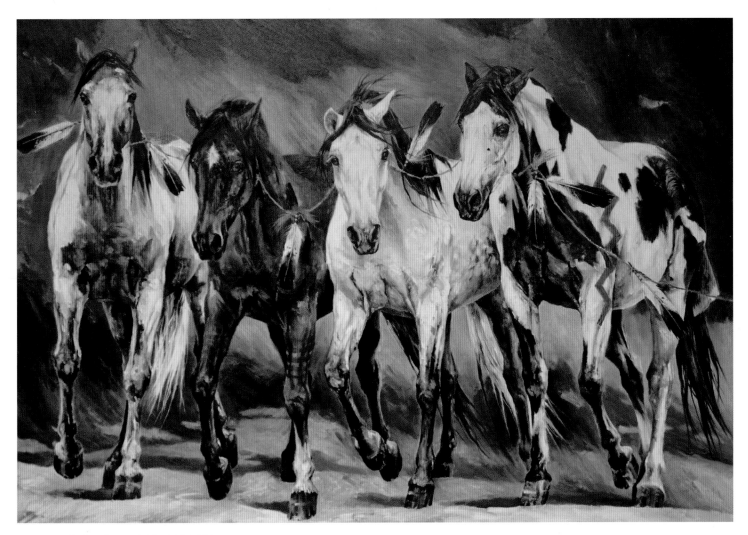

Moonrise - Indian Ponies. 52" × 72". 2004.

JOHN FAWCETT

CLARK, COLORADO

From an early age, I loved to draw and paint, and spent countless hours pursuing this hobby with encouragement from my parents. I drew in school, at home, outside, and perhaps when I should have been studying. I supplied artwork for the school newspaper, the yearbook, and club projects.

When I started my own veterinary practice, I continued to draw and paint at night and on my days off. My wife, Elizabeth, constantly encouraged me. After submitting work to some galleries and invitational shows, I was accepted, which further nurtured my art journey. This passion became so profound that I made the decision in 1996 to sell my practice to paint full time, which I thought was the only way to become a better artist. I have now been an artist longer than I was a veterinarian.

A good friend of ours is an engineer, and I am constantly amazed at how he looks at the world around him. As an artist, my view of the world around me is quizzical too, but I am fascinated by the shapes, colors, values, and light, and how they affect the subject. As artists, it is our job not to copy what we see, but to evoke an emotion, a memory, or a point in time with a drawing or brush strokes in paint. I am continually learning, developing, and, hopefully, growing as an artist.

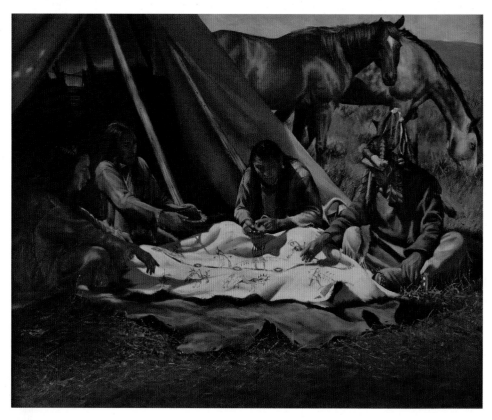

Telling the Winter Count. Oil. 24" × 30".

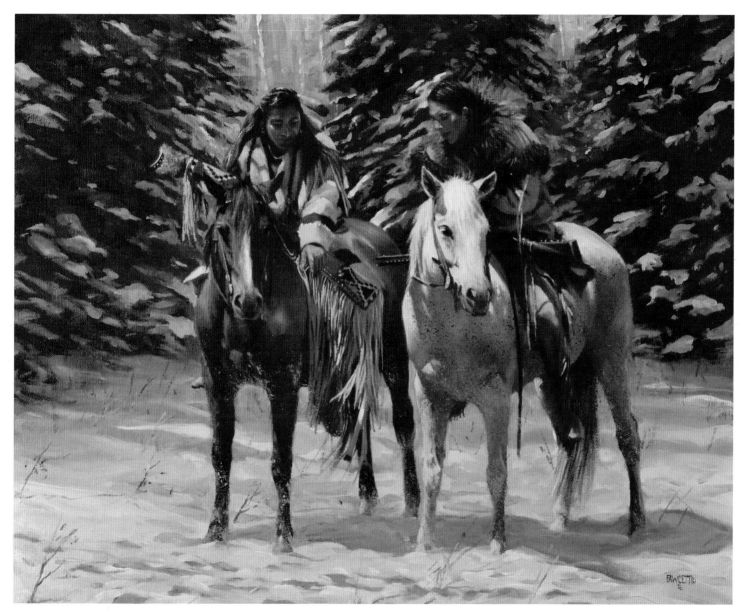

Ute Hunters. Oil. 16" × 20".

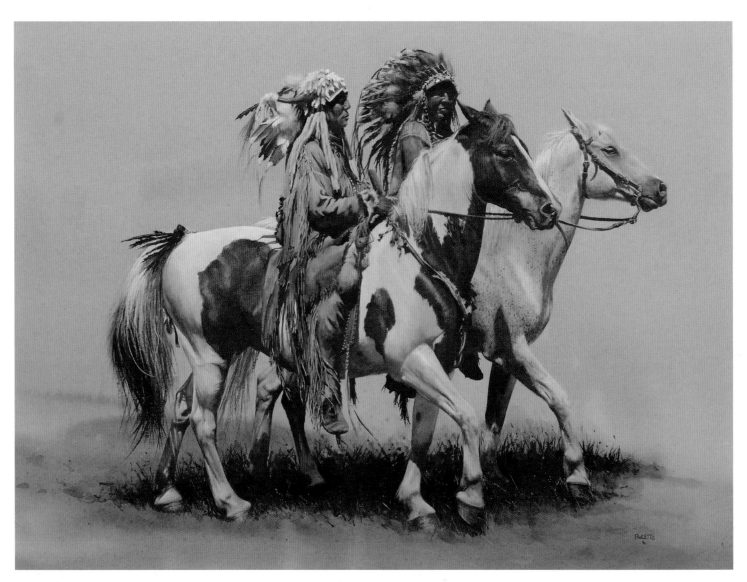

To the Council. Watercolor. 21" × 28". 2010.

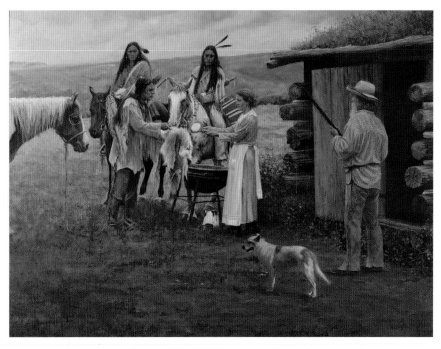

The Mirror Trade. Oil. 30" × 40".

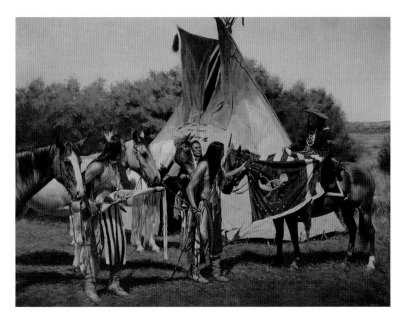

The Chief's Flag. Oil. 36" × 48". 2012.

FRED FELLOWS

SONOITA, ARIZONA

In Ponca City, Oklahoma, I lived near the 101 Ranch and the culture of the Otoe and Osage Native Americans. When I was nine years old, my family followed the Dust Bowl exodus to California, but each year I returned to Oklahoma and spent my summers with my grandparents in their art-filled home.

In the '50s, while living in California, I learned how to handle horses, rope cattle, and build saddles. I was a cowboy determined someday to break loose and be free. I honed my art skills at the Art Center School in Los Angeles and eventually became art director for Northrop Aircraft.

Early on I traded my paintings for groceries and doctor bills. By the late '60s, I had established a sound regional reputation and was breaking into the mainstream market. In 1969, I was invited to join the Cowboy Artists of America. It has been a wild ride ever since!

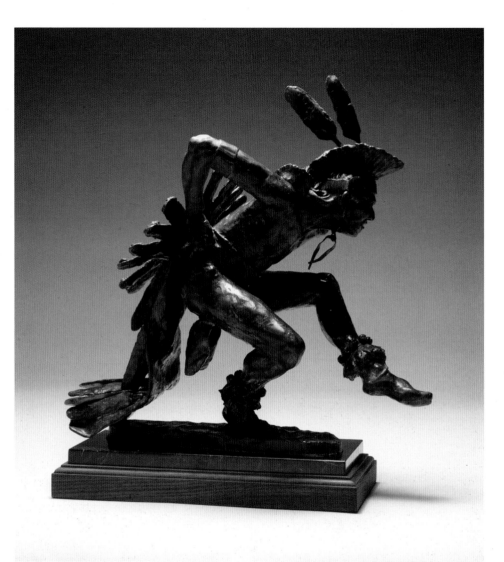

Dancing Back the Past. Bronze. 15" × 16".

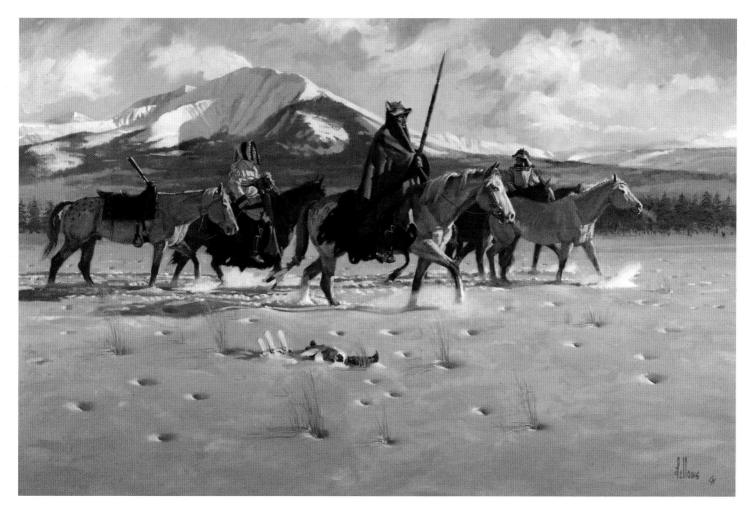

Wolves of Winter. Oil on canvas. 24" × 40".

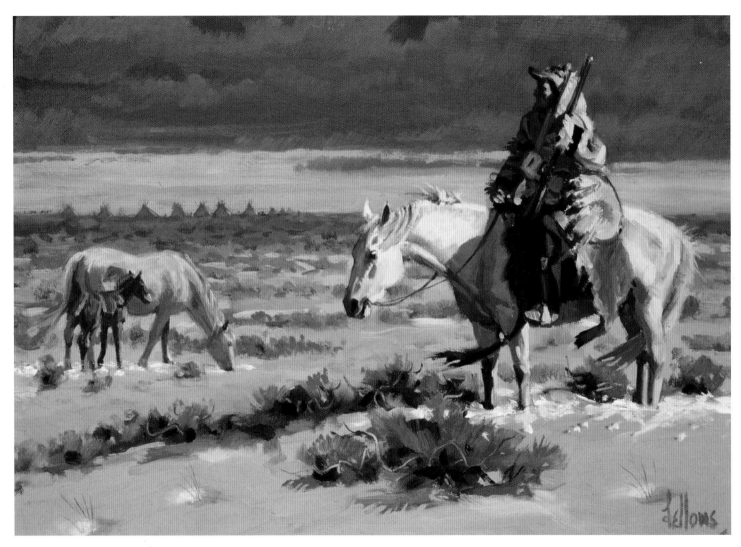

Guarding the Winter Camp. Oil on canvas. 24" × 36".

The River Keeps Secrets. Oil on canvas. 30" × 40".

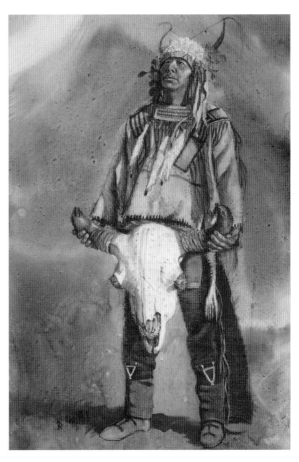

The Medicine Man. Comté drawing on paper.

CHARLES FRITZ

BILLINGS, MONTANA

Natural history and human history are bound together in such a symbiotic relationship that I cannot imagine a time when I will not be intrigued by it. Painting the natural world allows me to admire creation and all of the forces that have formed it; across this landscape march the generations of humankind, their endeavors empowered by their adaptable, indomitable human spirit. My mind and imagination are in a constant flow between art, history, and the landscape. It is fascinating to look out over the land and contemplate all of the centuries' worth of human activity that has taken place in that thin slice of nature where earth meets air. There are so many cultures, so many human stories, and such a constant and beautiful relationship between the land and her people. It is my privilege to do paintings that speak to this relationship, and to honor the great mystery of its creator.

Photos by Photographic Solutions

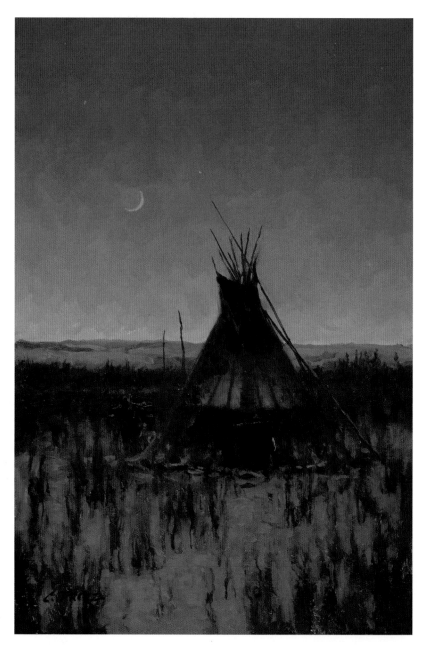

Cree Camp—Saskatchewan River. Oil. 12" × 8".

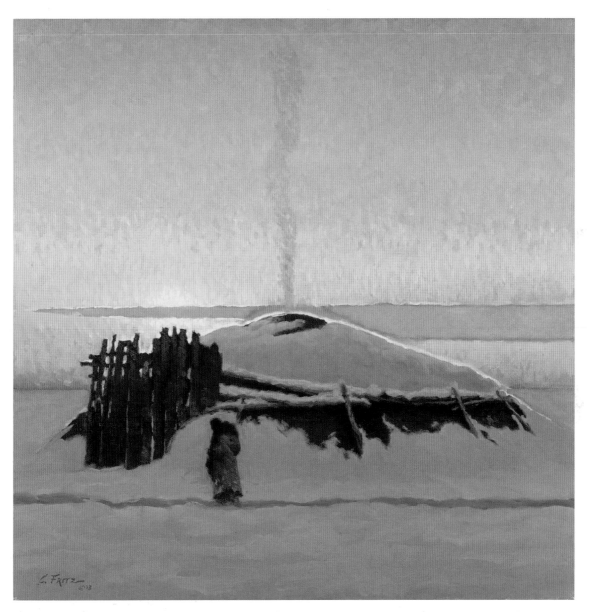

Hidatsa Lodge on the Knife River. Oil. 22" × 22". 2013.

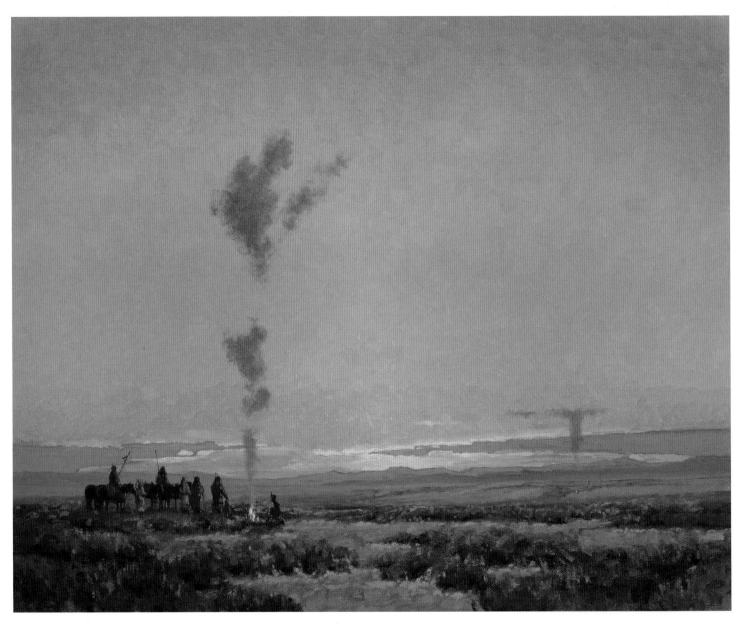

Good News. Oil. 16" × 20".

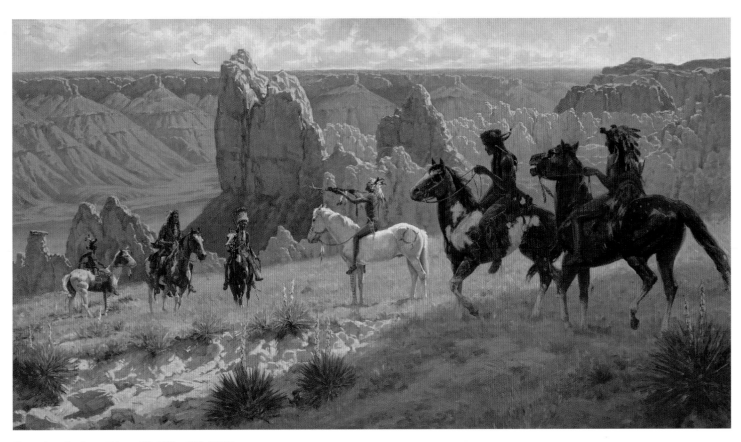

Honoring the Great River. Oil. 36" × 65". 2015.

MARTIN GRELLE

CLIFTON, TEXAS

I was born and raised in Clifton, Texas, and still live on a small ranch a few miles from town. My studio sits in the picturesque Meridian Creek valley, surrounded by the oak- and cedar-covered hills of Bosque County just a short distance from my home, but also within a few miles of my family and friends.

I began drawing and painting when I was very young, and was fortunate to have James Boren and Melvin Warren, two professional artists and members of the prestigious Cowboy Artists of America, move to the area when I was still in high school. Mentored by Boren, I had my first one-man show at a local gallery within a year of graduating from high school in 1973. In the nearly forty-four years since that time, I have produced some thirty one-man exhibitions, including twenty-six consecutive annual shows at Overland Gallery in Scottsdale, Arizona, and have won awards both of regional and national importance at shows around the country.

I was invited into membership of the Cowboy Artists of America in 1995, fulfilling a dream began in the early '70s, when I first met Boren and Warren. That same year I was invited to participate in the first Prix de West Invitational at the National Cowboy & Western Heritage Museum in Oklahoma City. Since that time, I have won multiple awards and been published frequently.

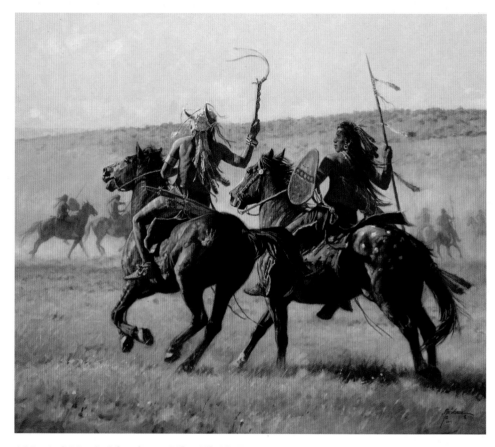

A Warrior's Worth. Oil on linen. 36" × 42". 2017.

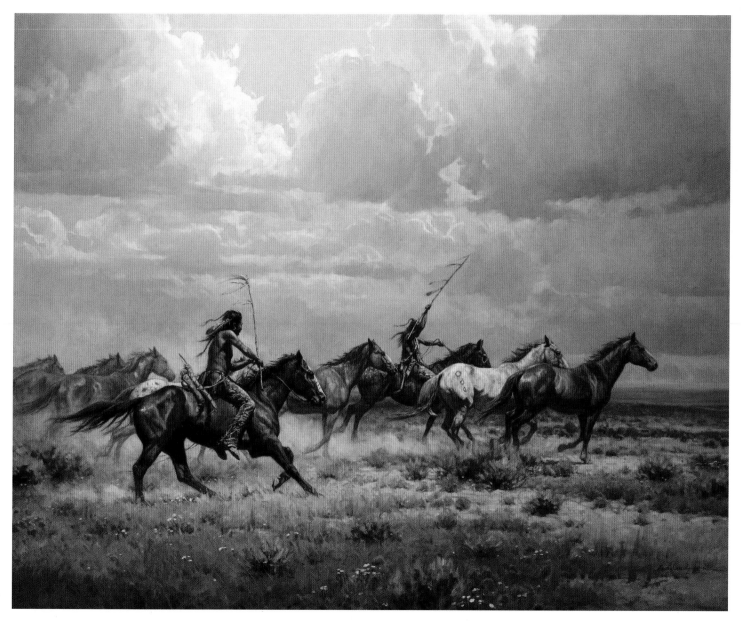

Running with the Elk-Dogs. Oil on linen. 48" × 60". 2007.

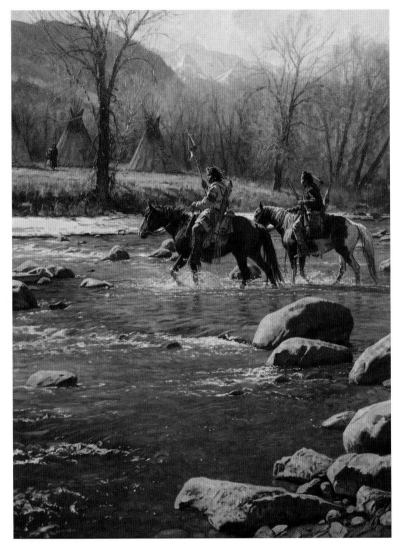

Return to River Camp. Oil on linen. 40" × 30". 2017.

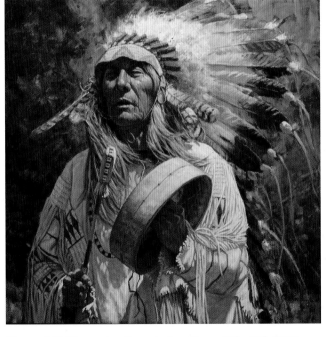

Singer of Old Songs. Acrylic and oil on linen. 24" × 24". 2017.

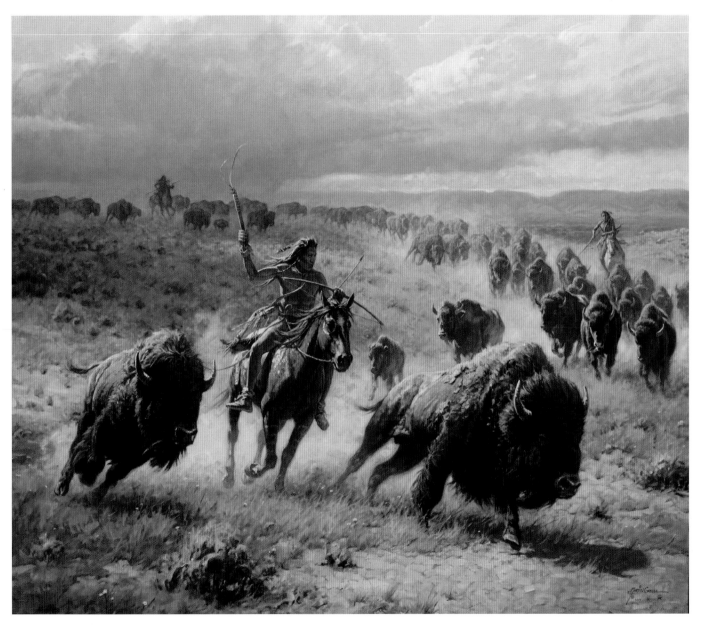

Chasing Thunder. Oil on linen. 46" × 54". 2017.

ROBERT GRIFFING

GIBSONIA, PENNSYLVANIA

Since I was a kid, I have been fascinated with the early native people: how they lived, what they looked like, and how they dressed. After a thirty-year career in advertising, I returned to my early fascination, and I was able to bring that childhood interest to life after extensive research. My paintings of eighteenth-century Great Lakes and Eastern Woodland Indians have been the most rewarding experience of my life. The acceptance of my work by my patrons and the native people themselves is the driving force that keeps me going. I will always value their friendship.

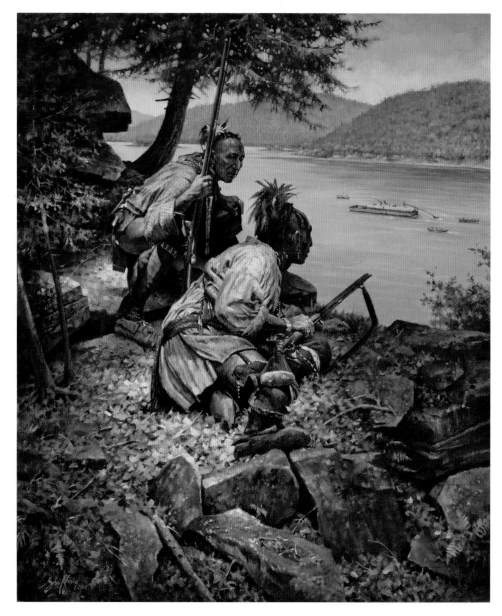

The Newcomers. 36" × 30". *Courtesy of Alexander Patho Photography*

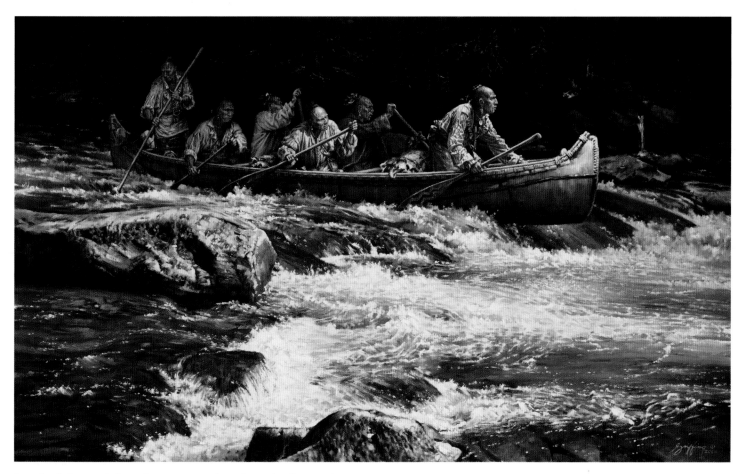

Into the Unknown. 30" × 50". *Courtesy of Alexander Patho Photography*

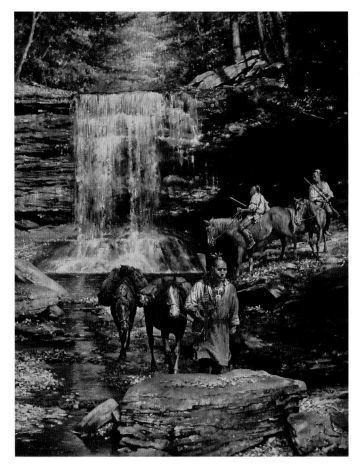

Autumn Journey. Oil on canvas. 48" × 36". *Courtesy of Booth Museum*

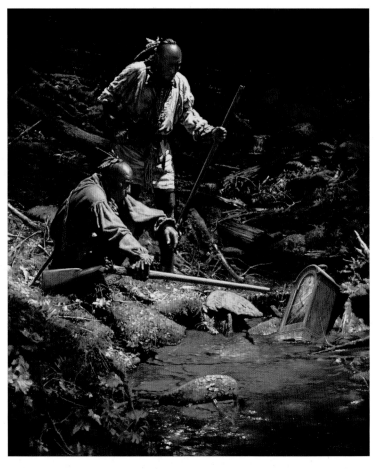

Only a Matter of Time. 50" × 42". *Courtesy of Alexander Patho Photography*

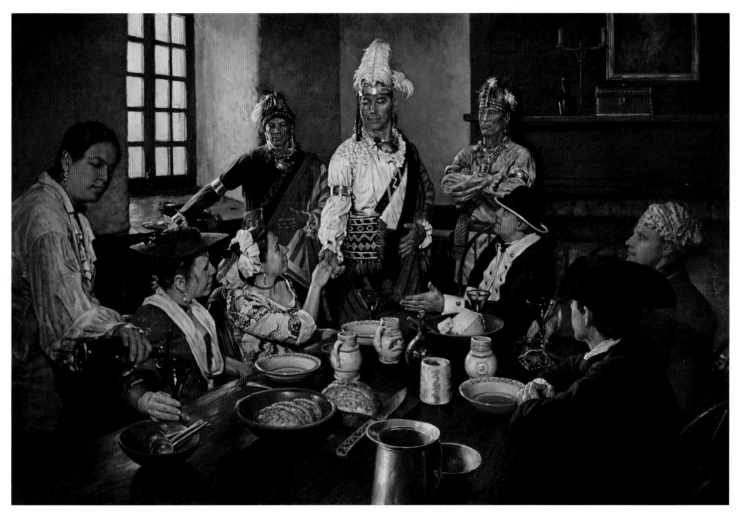

The Introduction. 40" × 60". *Courtesy of Alexander Patho Photography*

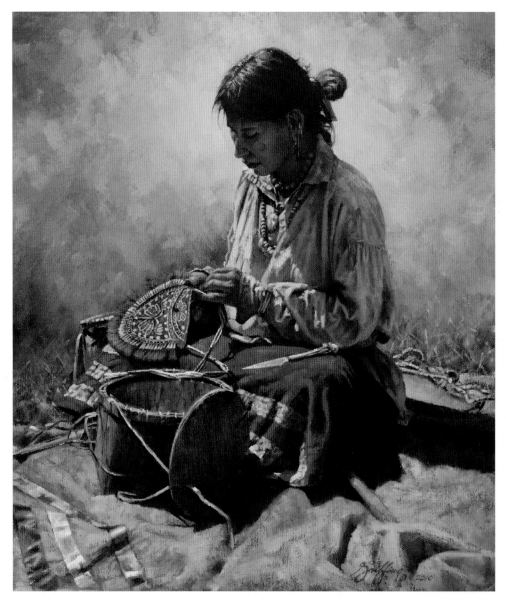

Her Mother Taught Her Well. 22" × 19". *Courtesy of Alexander Patho Photography*

LOREN MAXWELL HAGEGE

WOODLAND HILLS, CALIFORNIA

Serious study in art began when my early interest in animation led me to a local art school, Associates in Art. My interest quickly moved from animation to fine art while attending life drawing classes and, later, the academy's advanced master's program, in which students spent more than six hours each day drawing and painting live models. I also studied privately with Steve Huston and Joseph Mendez.

I have drawn inspiration for my subjects from my native Southern California, as well as my extensive travels to view various landscapes in the American Southwest and the northeast coast of the United States. My subjects are modern American Indians living in the Southwest, as well as modern landscapes.

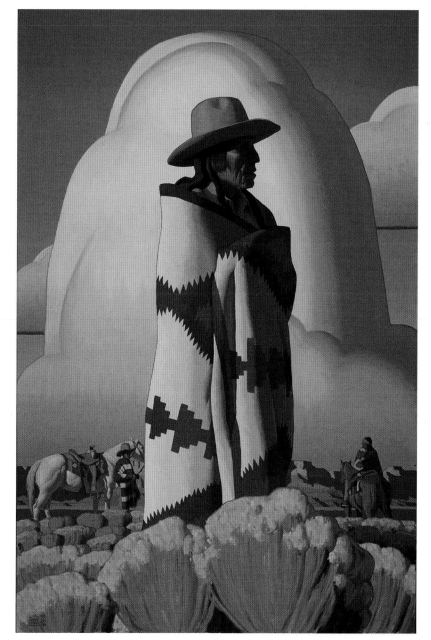

Bound to Ramble. 60" × 40". 2015.

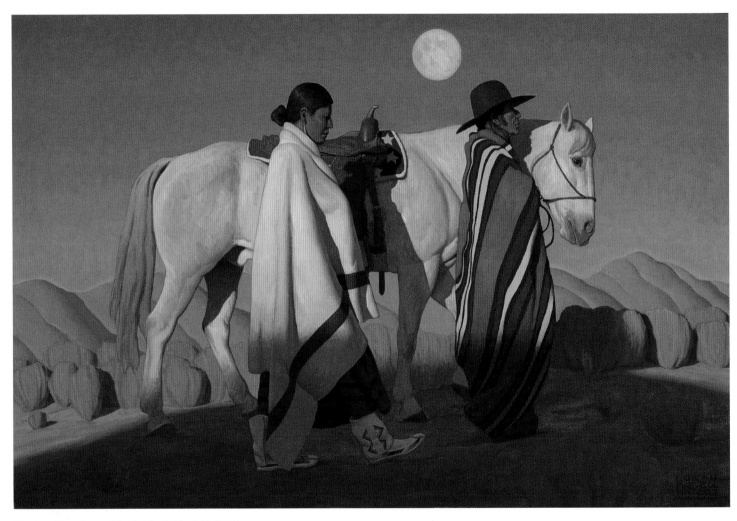

The Sun Must Set to Rise Again. 20" × 30". 2016.

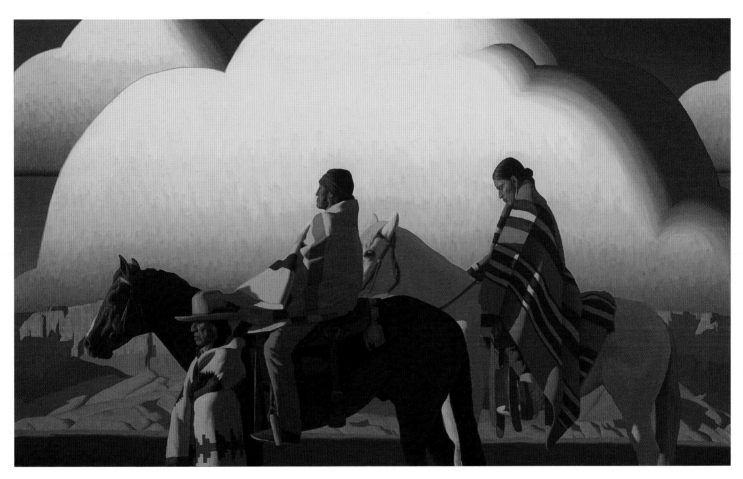

Across These Endless Skies. 30" × 50". 2015.

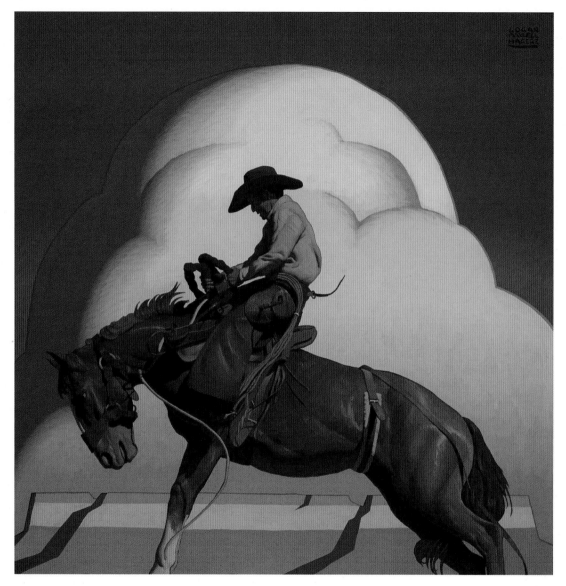

Mesa Rodeo. 30" × 30". 2014 .

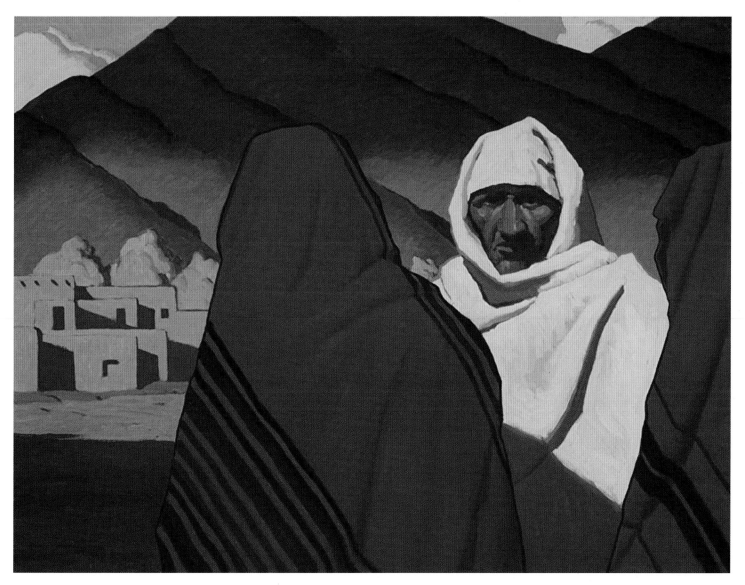

Shadows on the Mountains. 30" × 40". 2009. *Courtesy of the Booth Museum*

DOUG HYDE

PRESCOTT, ARIZONA

As a Native American sculptor, I believe all things have their own spirit. I work with stones to transform their shapes into a new life. Some stones want to be seen in feathers, and they become birds to soar above trees and clouds. Others want to feel their footprints and walk on all fours—deer, bears, and rabbits. The joy they bring me I want to share with you.

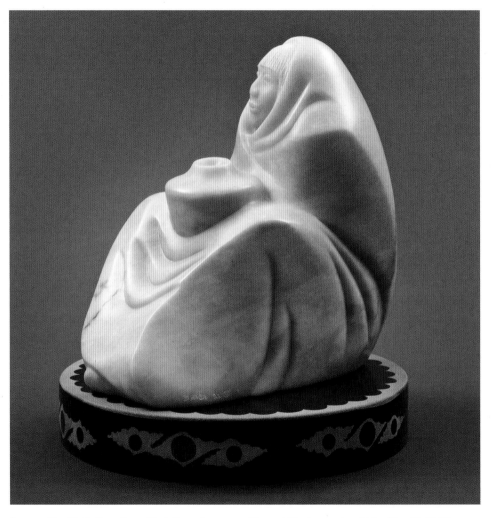

Potters Sing Their Own Song. Pink Portuguese marble and black steatite. 11" × 9" × 5". 2012.

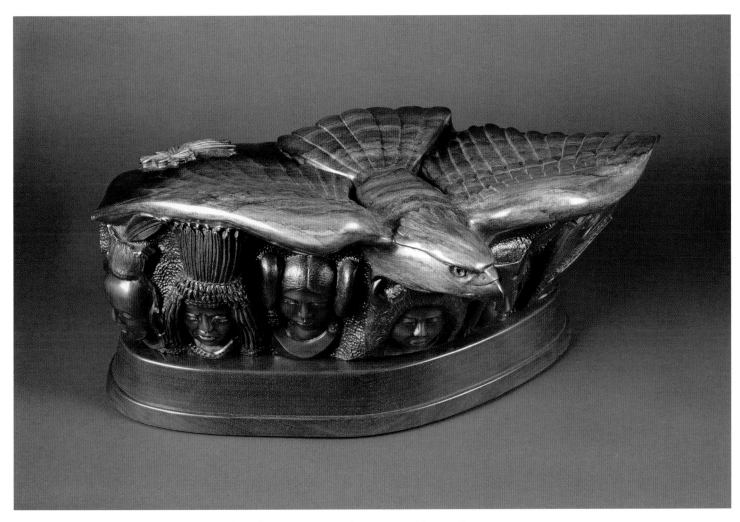

People of the Red Tail Hawk. Bronze. 62" × 76" × 40". 2012. *Courtesy of Larry Kantor Photography*

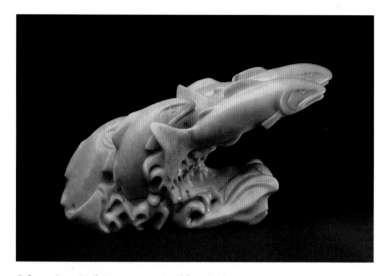

Salmon Run. Pink Portuguese marble. 16.5" × 30" ×
12". 2012. *Courtesy of Larry Kantor Photography*

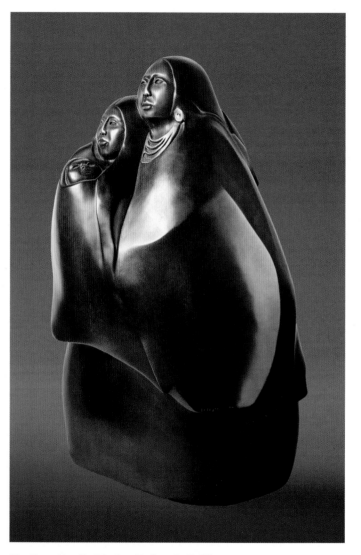

Nez Perce Family (Mother, Father, & Child).
Bronze. 29" × 20" × 13". 2002.

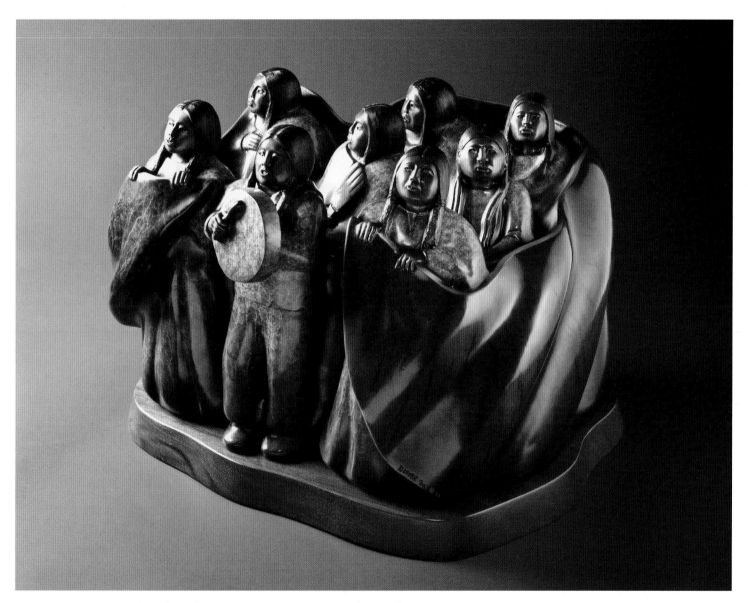

Honor Song. Bronze. 14.5" × 24" × 18". 2012. *Courtesy of Larry Kantor Photography*

ORELAND C. JOE SR.

KIRTLAND, NEW MEXICO

I feel that as an artist I am also a historian, storyteller, and cultural teacher. I am constantly sharing information through my artwork in sculpture, painting, and jewelry. Ideas seem to blossom each time I hear traditional songs or attend cultural gatherings. Much can be shared with the youth of today to help them understand their own cultural identity through art activities.

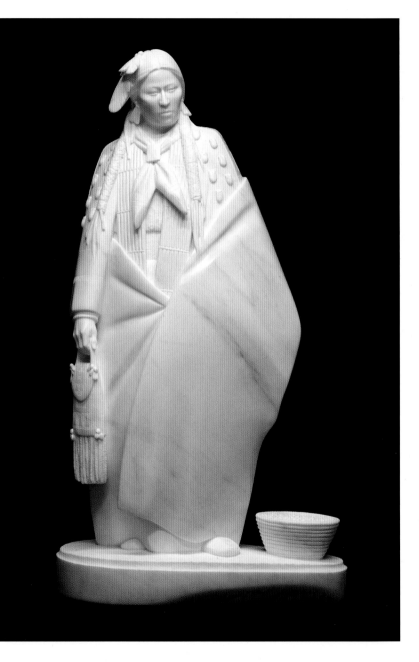

Choke Cherries along the Pine River. Italian marble. 36". *Photo by Oreland Joe Jr.*

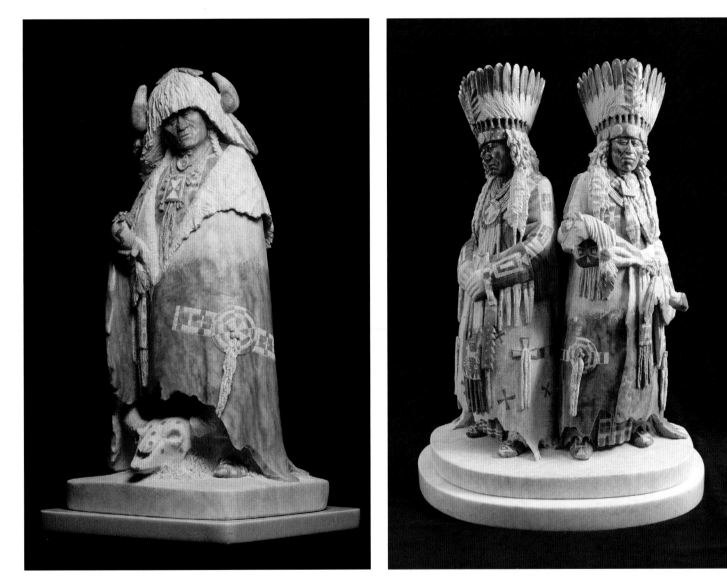

Thunder on the Plains. Alabaster. 28". *Photo by Oreland Joe Jr.*

Blackfoot Horsemen. Alabaster. 23". *Photo by Oreland Joe Jr.*

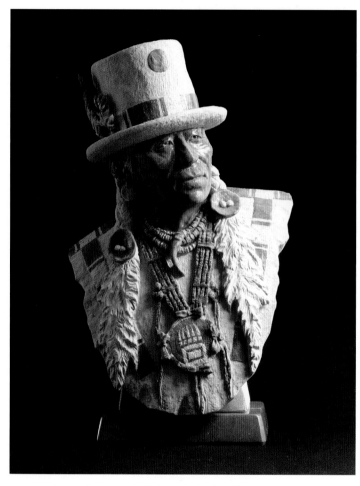

Bear Medicine. Alabaster. 17". *Photo by Oreland Joe Jr.*

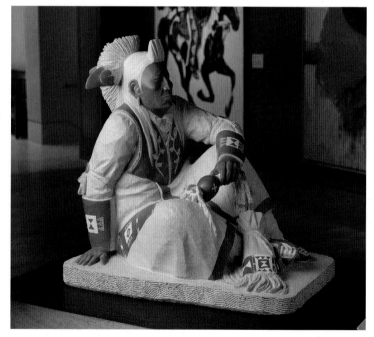

Healing Songs. Marble. 24" × 17" × 24". 2000. *Courtesy of Booth Museum*

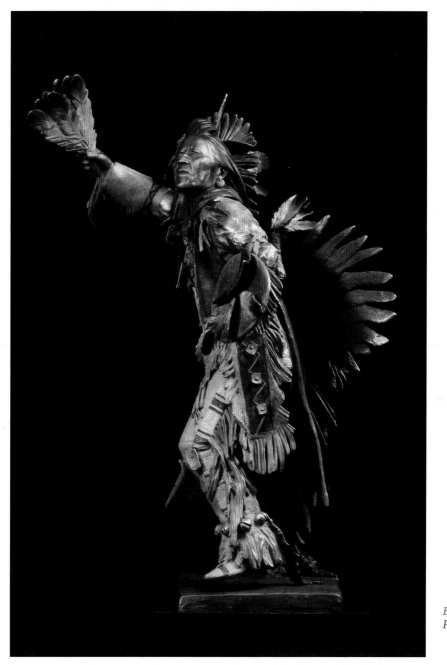

Buffalo Tail. Bronze. 25".
Photo by Oreland Joe Jr.

Z. S. LIANG

AGOURA HILLS, CALIFORNIA

The concepts of self-sufficiency and solitude, which were commonplace in the lives of the American Indian, are profoundly intriguing to me. When I consider the many hardships and the instability of their wild environment, my imagination brings me many and varied themes to build painting ideas upon. The thought of the lone hunter as a true son of Mother Nature pitting himself against the odds can be a powerful and fascinating story. Not only is the hunter faced with the constant and often-desperate task of being a provider, but he also must be proficient at the complicated fabrication of the very weapons and tools vital to the hunt. Skill and inventive creativity were very much a part of all that these people did, as symbolized by the canoe, the bow, and the hammered-copper earrings worn by these resolute huntsmen.

I received my great inspiration in this country while studying and painting the Wampanoag Indian culture at the outdoor museum in Plymouth, Massachusetts. This interest fired my imagination, and I began to focus my painting primarily on Native American Indian cultures and their traditional ways of life. During the ensuing years of field research, I have made many connections and friends among native tribes from the East Coast to the West.

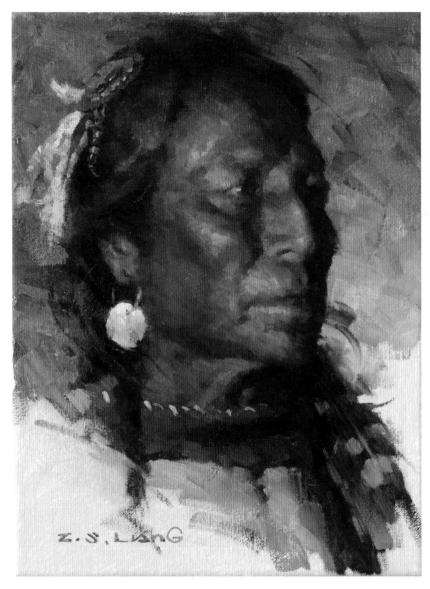

Blackfeet Elder. Oil on linen. 12" × 9". 2008.

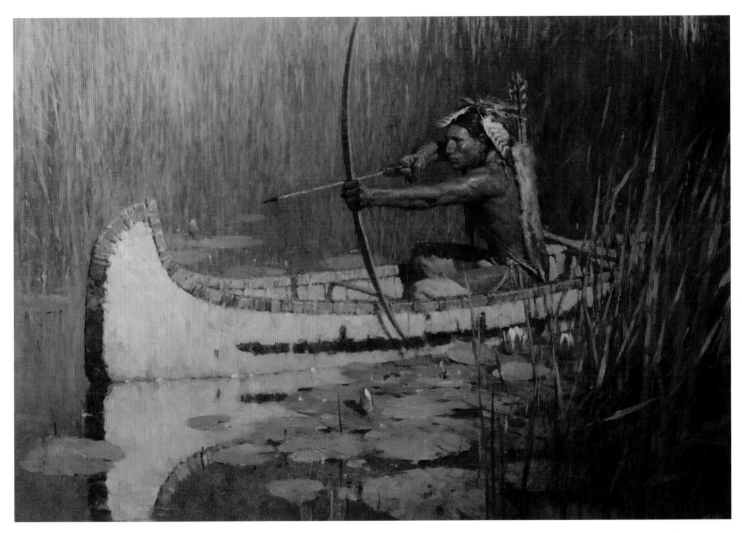

Solitary Hunter. Oil on linen. 36" × 54". 2005.

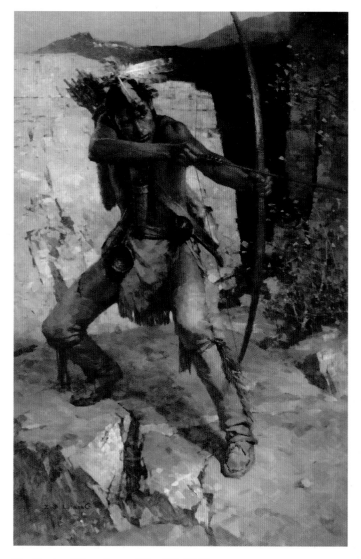

The Hunter. Oil on linen. 46" × 30". 2007.

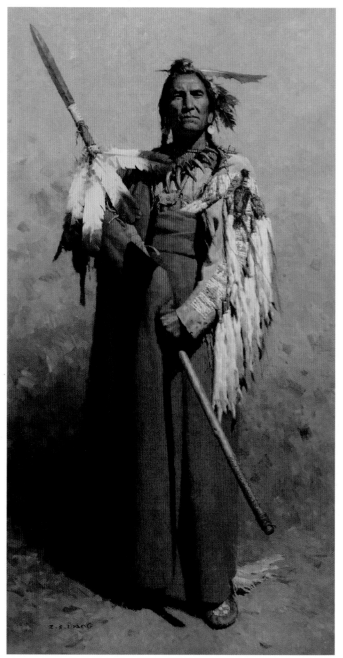

Pride of the Blackfeet. Oil on linen. 60" × 32". 2009.

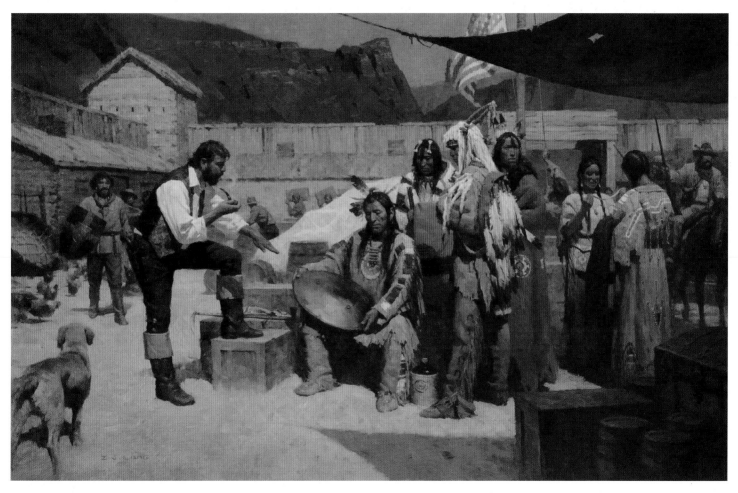

Rejecting the Metal Shield, Fort MacKenzie, 1835. Oil on linen. 46" × 72". 2010.

JEREMY LIPKING

AGOURA HILLS, CALIFORNIA

The son of painter and illustrator Ronald Lipking, I became interested in art as a young child. I soon enrolled in the California Art Institute, where I devoted myself to serious study.

I am most drawn to the desert and mountain wilderness of the American Southwest, spending much of the summer gaining inspiration by sketching and painting on location, where I often combine the human figure and landscape of the Southwest into a single work. I am an enrolled member of the Keweenaw Bay Indian Community of the historic Lake Superior Band of Chippewa Indians.

Riders under Vermilion Cliffs. Oil on linen. 30" × 40". 2014.

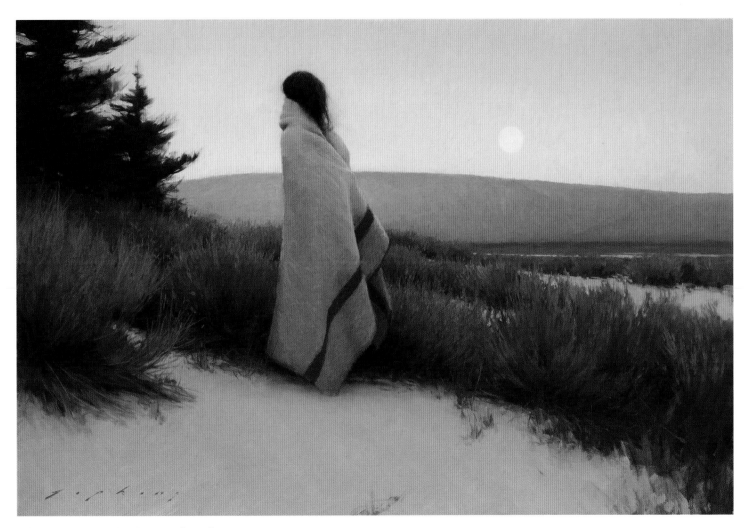

Whispering Pines. Oil on linen. 20" × 30". 2014.

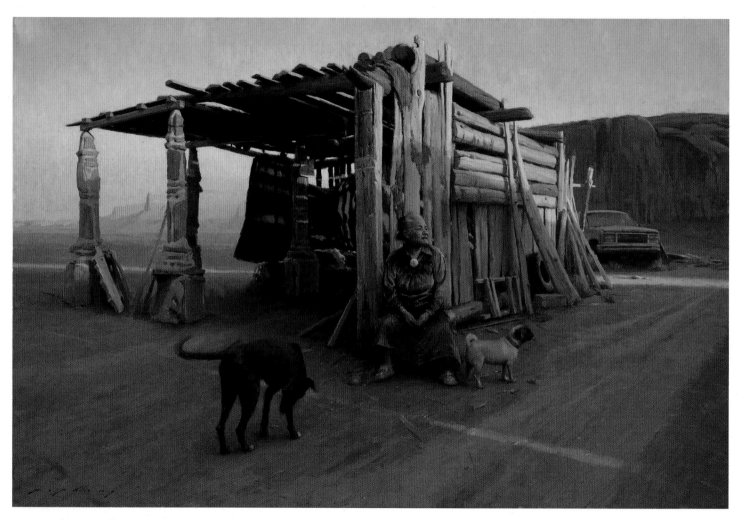

Between the Past and Present. Oil on linen. 40" × 60". 2016.

Flor de Muertos. Oil on linen. 40" × 70". 2011.

LeAnn. Oil on linen. 20" × 16". 2016.

DAVID MANN

LOGAN, UTAH

Even as a child, I seemed to be attracted to the Indian theme. I sat at my mother's feet and listened as she read from S. N. Wilson's engaging "White Indian Boy," and was swept away by Howard Driggs's lively illustrations. For Christmas and birthdays, I received American Heritage Books featuring art by Miller, Catlin, Leigh, Remington, Russell, Johnson, and others that created a dreamworld of American Indian images spread across the landscape of my mind.

As a nineteen-year-old Mormon, I was called by my church to spend two years as a missionary among the Indians of Arizona and New Mexico, an experience that seemed custom-made for me. I learned to love the Indian people and their culture even as they struggled to cope with many sorrows and difficulties.

I would like to think that my work always links back to the humanity of Indians; a real people because that is how I know them. I hope my work can portray some of the beauty, magic, and wonder of the historic Native American world as I have seen it in my mind ever since I was a child listening to S. N. Wilson's words describing his departure with the Indians, "I jumped on my horse and away we went."

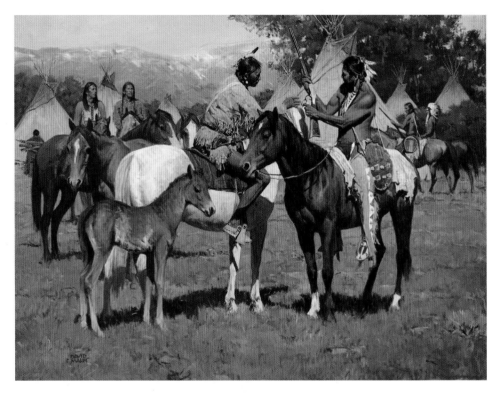

Yellow Boy Winchester. 36" × 48". 2014. *Courtesy of Frank Prince*

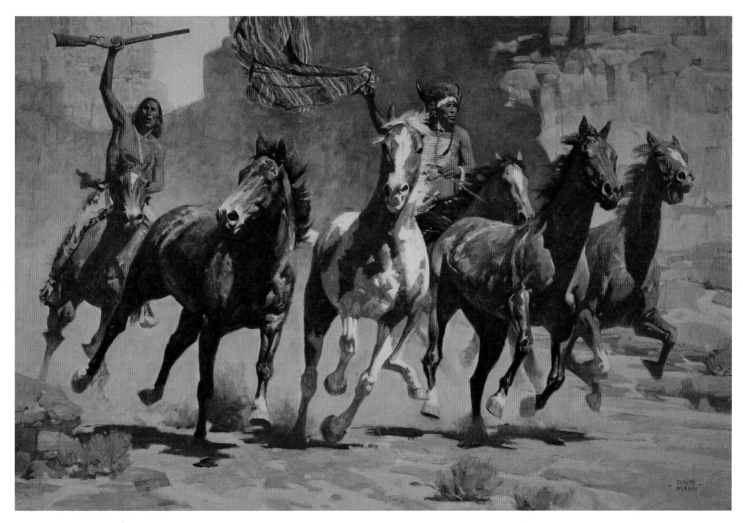

Mustang Canyon. 40" × 60". 2007. *Courtesy of Frank Prince*

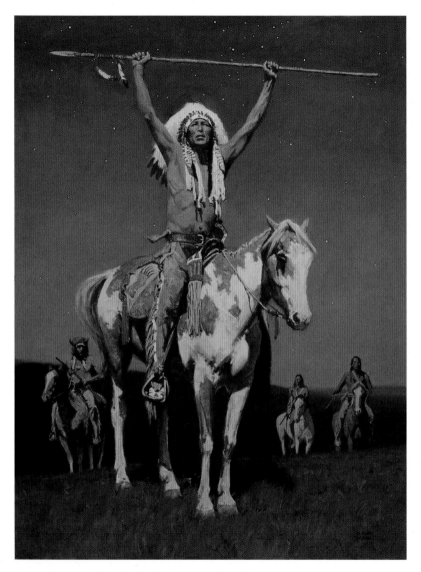

Moon Blessing. 40" × 30". 2016. *Courtesy of Frank Prince*

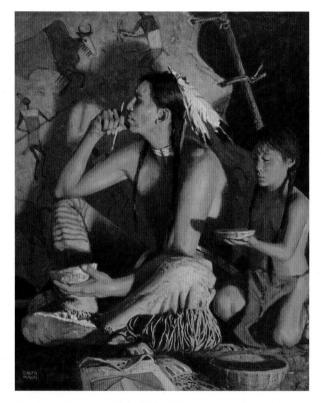

Moment of Courage. 36" × 24". 2016. *Courtesy of Frank Prince*

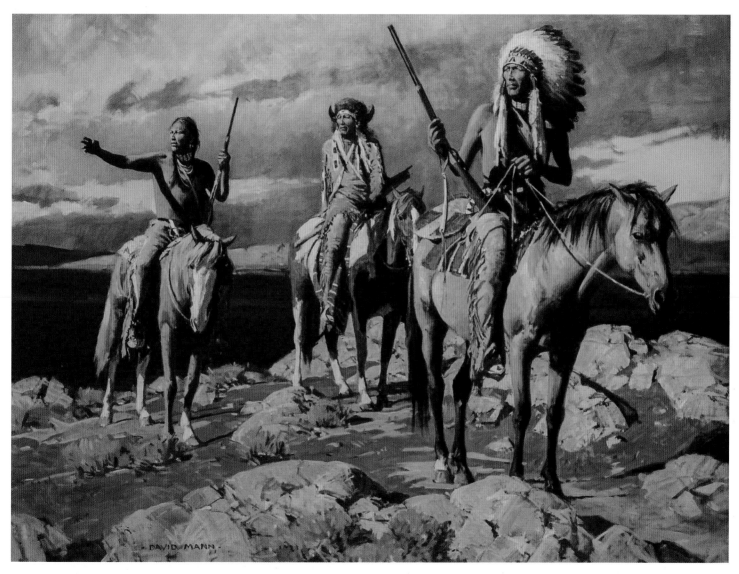

Signs in the Sun. 30" × 40". 2005. *Courtesy of Booth Museum*

ALLAN MARDON

TUCSON, ARIZONA

My journey began in the classrooms of Toronto, Edinburgh, and London and continued in the canyons of New York City. For twenty-five years, my days were filled with design assignments from corporate giants such as AT&T, *Time*, and *Sports Illustrated*.

After moving to the Southwest, I was inspired to begin a series of narrative paintings that depict the history, culture, and spirituality of Native Americans. Influenced by the storytelling elements of cave paintings, hieroglyphics, and ledger drawings, as well as the works of Paul Klee and Joan Miró, I am able to portray multiple images in a cohesive manner so that even the most complicated story is accessible. These paintings and their subjects have become one gigantic historical and spiritual lesson for me. Painting these scenes has made my own life a quest.

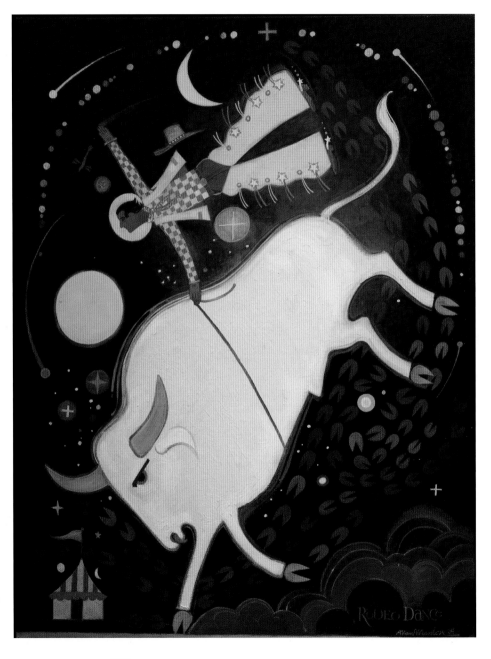

Rodeo Dance. Oil on panel. 42" × 32". 2005.
Photo by Jack Kulawik

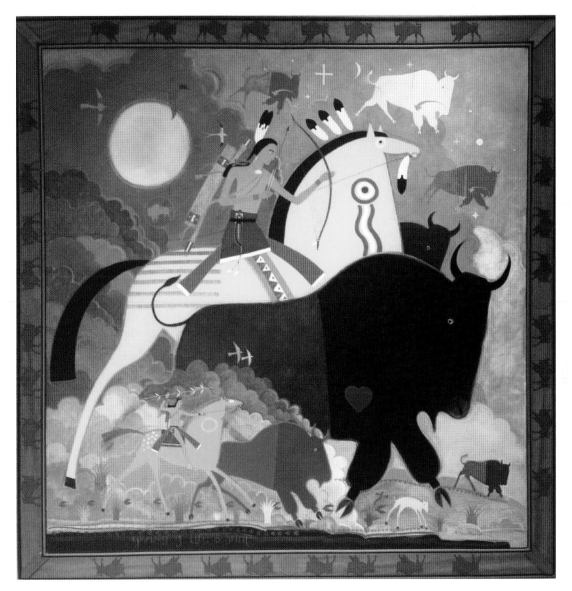

Giving of Life and Spirit. Oil on canvas. 68.25" × 68.25". 2005. *Courtesy of Booth Museum*

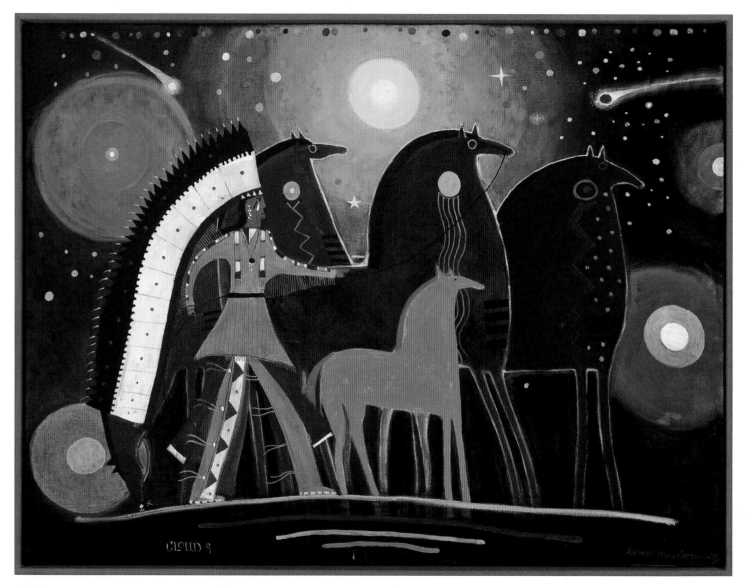

Cloud 9. Oil on Belgian linen. 31" × 41". 2015. *Photo by Jack Kulawik*

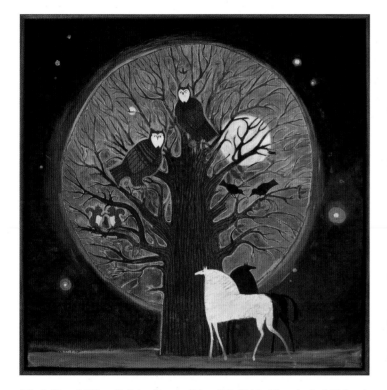

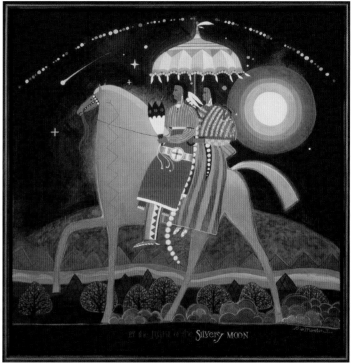

Who's There? Oil on Belgian linen. 42" × 42". 2015. *Photo by Jack Kulawik*

By the Light of the Silvery Moon. Oil on Belgian linen. 40" × 40". 2005. *Photo by Jack Kulawik*

KRYSTII MELAINE

Colbert, Washington

Combining my classical training in portraiture with my fascination for Native American people and the history of the American West brings my artistic journey full circle. As an Australian, I am like the early explorers, discovering people and places previously unknown to me. I dream and imagine what Native American life might have been like and how to portray it artistically. Studying the details of historical clothing and equipment, making my own replica items from hide and beads, and naming my paintings in the language of the depicted tribe make my process much more involved than just creating images. I work with models and horses on location in natural light, setting up situations and poses that tell stories ranging from simple to complex, universal to personal. In the studio, I strive to translate what I saw and felt into an artistic interpretation that is visually and emotionally beautiful. Technically, I focus on the realism of the faces, quality of the brushstrokes, and richness of color and tone.

Presenting each person in their own space, where their beliefs and experiences can be read in their clothing and on their faces, is essential to my artistic fulfilment. The people who inhabit my paintings are individual personalities with a life lived and stories to tell worthy of a formal portrait, deserving of our attention, and fascinating to know or wonder about.

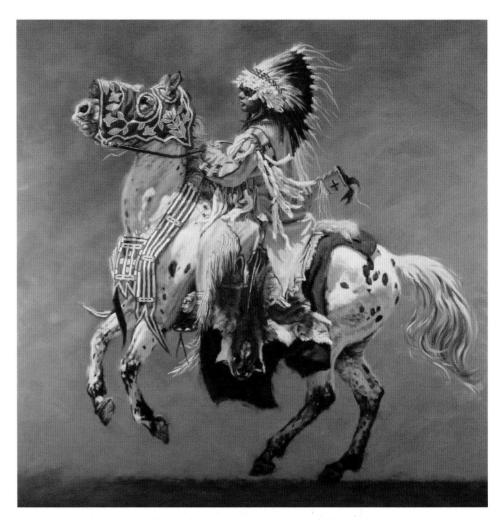

Támtl'aki Kw'ayawi—Spotted Horse & Mountain Lion, Yakama. Oil on linen. 44" × 44". 2015.

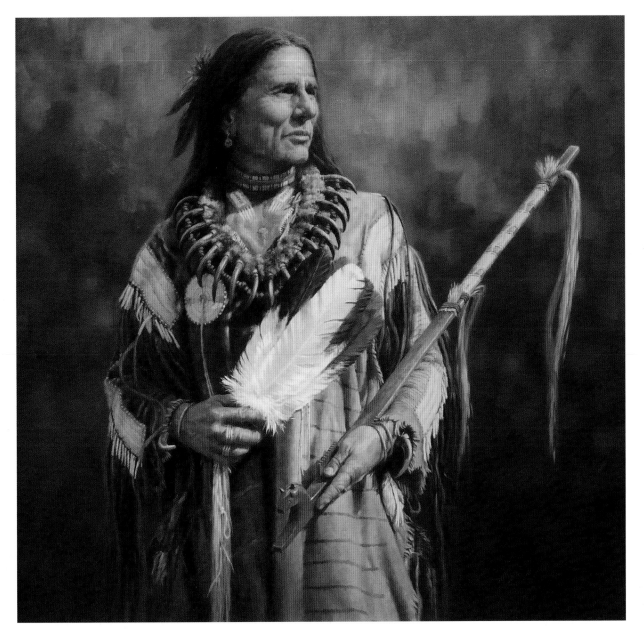

War and Peace. Oil on canvas. 38" × 38". 2008. *Courtesy of Booth Museum*

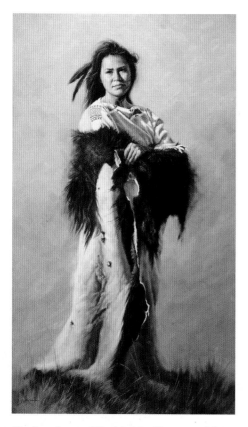

Haa'havehane—Wind Spirit, Cheyenne. Oil on linen panel. 48" × 28". 2016.

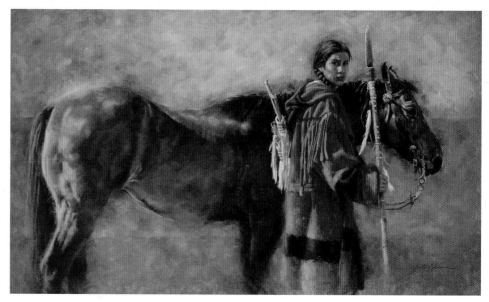

Mi'kisspiksísoka'sim—Red Coat, Blackfeet. Oil on linen panel. 20" × 34". 2016.

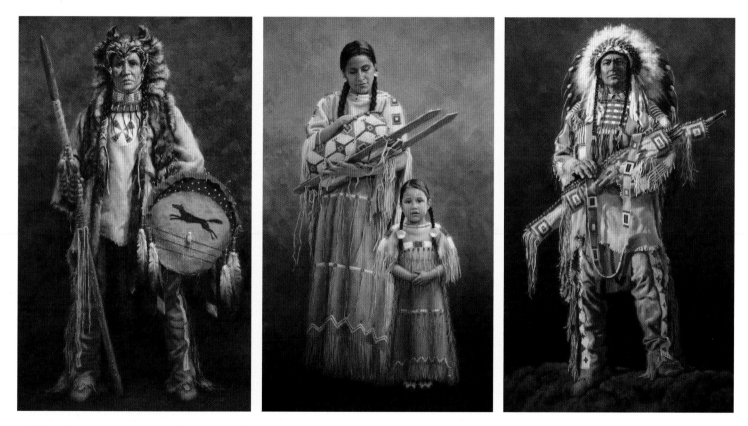

Left to right: *Sikómahkapi'si—Blackwolf, Blackfoot. Mehota—Love, Northern Cheyenne. Ohítika—To Be Brave, Lakota.*
Oil on linen. 72" × 44" each. Set of three. 2014.

JOHN MOYERS

SANTA FE, NEW MEXICO

I studied art at the Laguna Beach School of Art and the California Institute for the Arts on a Walt Disney Studio scholarship. Both of these schools stressed the fundamentals of drawing and good design. In 1979, I was invited to attend a monthlong painting session with several other artists at the Okanagan Game Farm in British Columbia, led by Robert Lougheed, one of the finest animal painters North America has ever produced. This was one of few places where an artist could study and paint in traditional techniques both domestic and wild animals from real life. The experience of painting *en plein* air day after day was a truly eye-opening experience in the way I approached a subject and captured it on canvas.

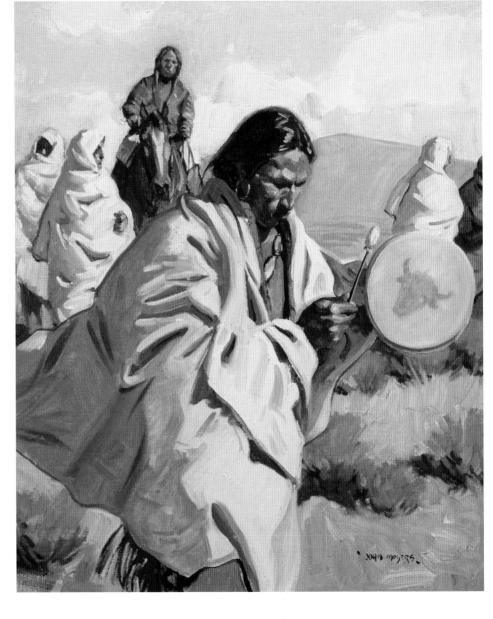

The Buffalo Drum. Oil on panel. 30" × 24". *Photo courtesy Mark Sublette, Medicine Man Gallery*

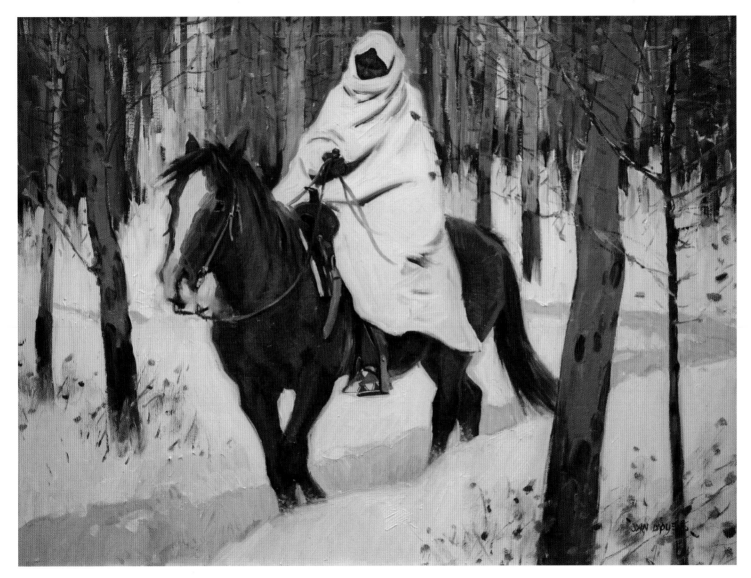

A Warm Fire Awaits Him. Oil on linen. 30" × 40". *Photo courtesy Mark Sublette, Medicine Man Gallery*

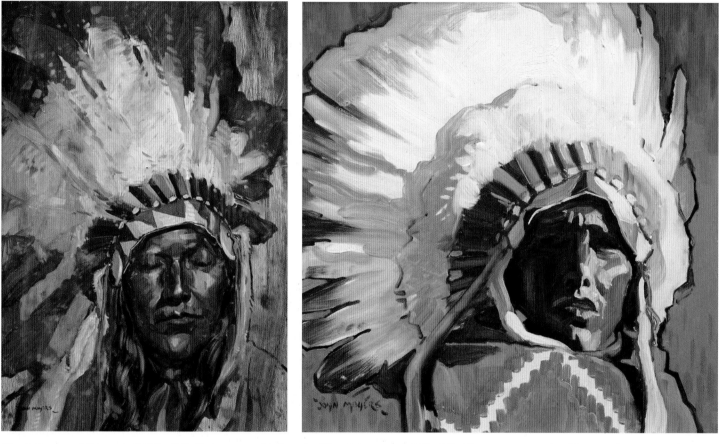

Mystic Journey. Oil on panel. 36" × 24". *Photo courtesy Mark Sublette, Medicine Man Gallery*

On Edge. Oil on panel. 24" × 24". *Photo courtesy Mark Sublette, Medicine Man Gallery*

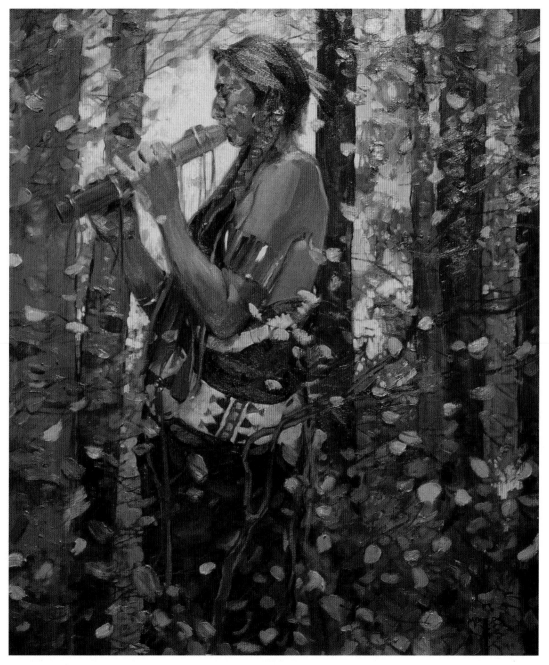

The Suitor's Song. Oil on canvas.
50" × 40". *Courtesy of Booth
Museum*

JOHN NIETO

NEW MEXICO

My paintings are my point of view on a subject that is very important to me personally. I paint Native American themes so I can step back in time and shine some light on those people and their culture. Through my artwork, I hope to show their humanity and their dignity, and I hope that point of view finds an audience that considers it of interest. With my work, I seek to evoke a reaction or response from the viewers, something they can truly connect with.

For me, becoming an artist was preordained. It is a vocation that made its way into my consciousness by way of my ancestry, as opposed to selecting a career path. You need to have potential for special awareness. One must be compelled to paint, and if you are, you find a way. For me, I employ a subject matter that is familiar and express it the way I see it. Through my art, I celebrate my faith that a profound life can be a happy one.

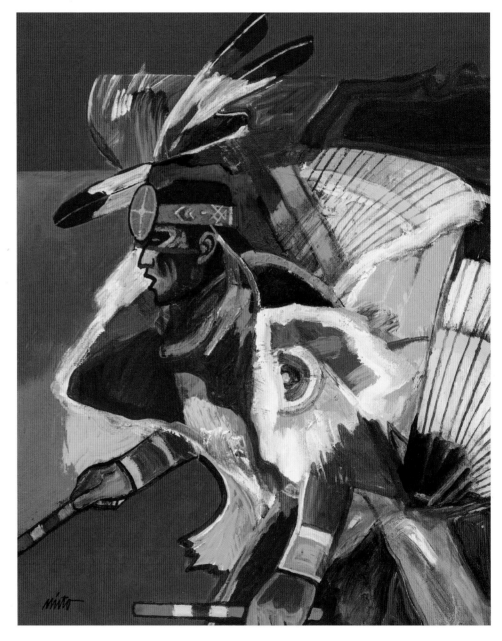

Native American Fancy Dancer. Acrylic on canvas. 30" × 24". 2016. *Photo courtesy of Anaya Nieto*

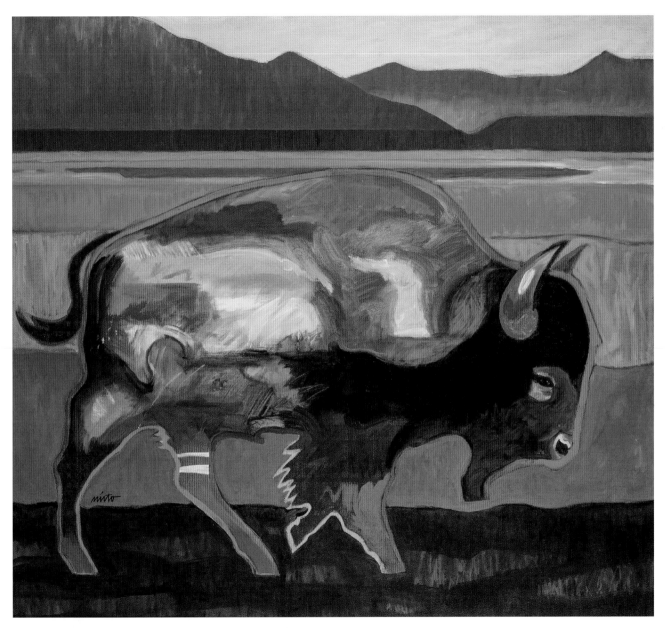

Buffalo in Foothills. Acrylic on canvas. 40" × 44". 2012. *Photo courtesy of Anaya Nieto*

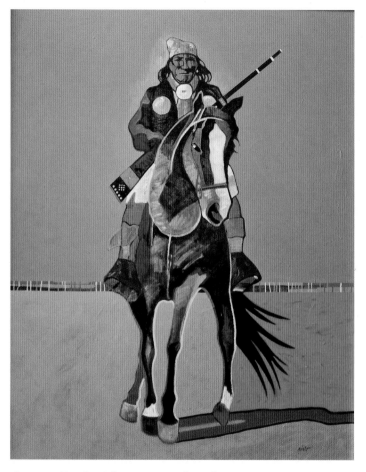

Geronimo/Apache. Oil on canvas. 60" × 48". 1995.
Courtesy of Booth Museum

Coyote in Tune with the Cosmos. Acrylic on canvas. 30" × 24". 2015.
Photo courtesy of Anaya Nieto

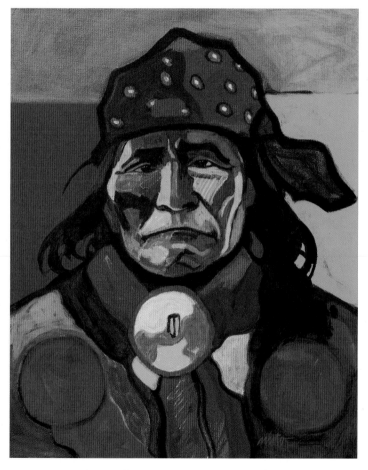

Geronimo, Apache. Acrylic on canvas. 20" × 16". 2016.
Photo courtesy of Anaya Nieto

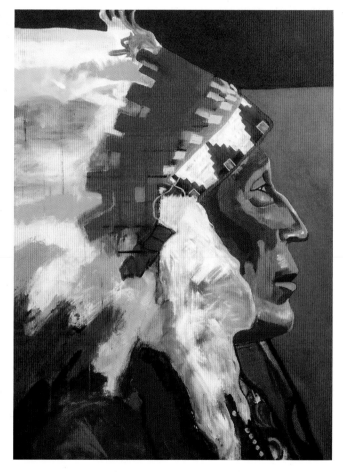

Chief Iron Tail. Acrylic on canvas. 40" × 30". 2016.
Photo courtesy of Anaya Nieto

JIM NORTON

SANTAQUIN, UTAH

Born in Price, Utah, I paint Indians, in real life, and their horses. I also collect authentic Plains Indian costumes.

I spent most of my youth in western Wyoming, where I gained a working knowledge of ranch life. In 1989, I became a member of the Cowboy Artists of America, dedicated to the painting tradition of Charles Russell and Frederic Remington. I am convinced that painting from life is what lends authenticity and vitality to my paintings. I paint ten to twelve paintings a year, often working on several at a time.

All images courtesy of Mike Snelson PhotoColor Lab

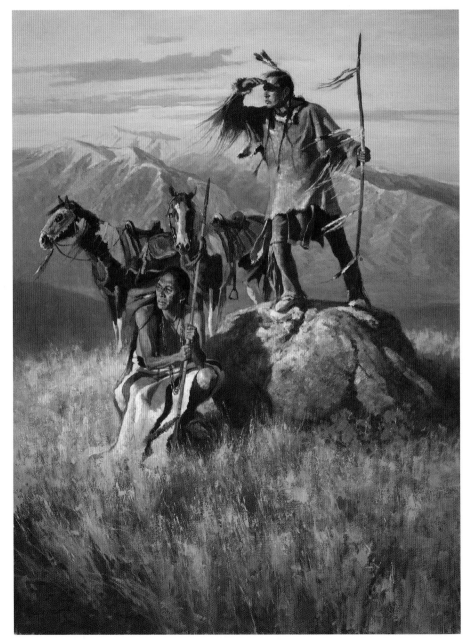

Lookout Rock. Oil. 52" × 38".

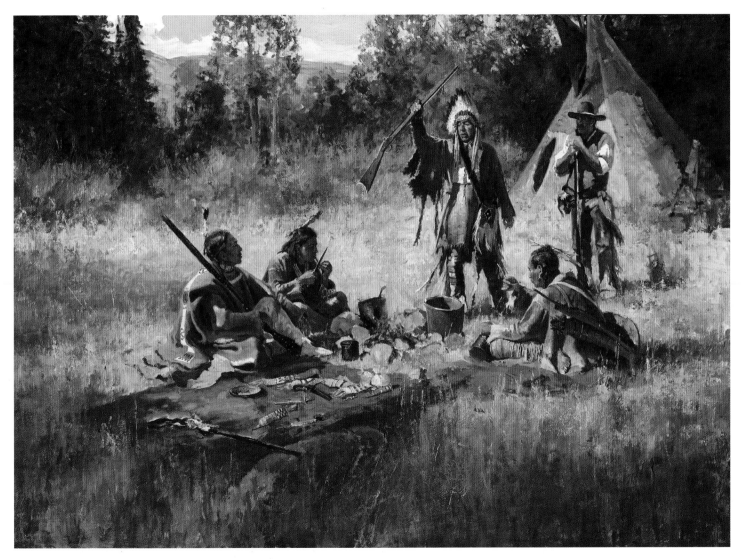

Bridger, Trading with the Lakota. Oil. 30" × 42".

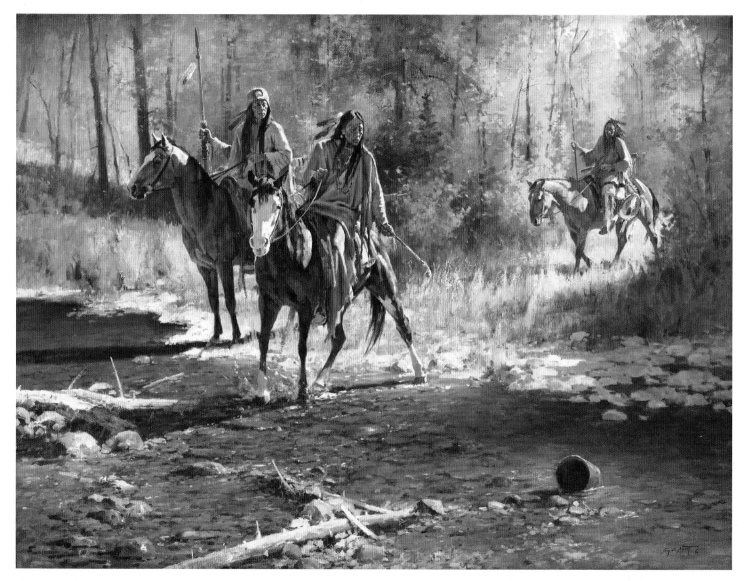

The Lost Bucket. Oil. 38" × 52".

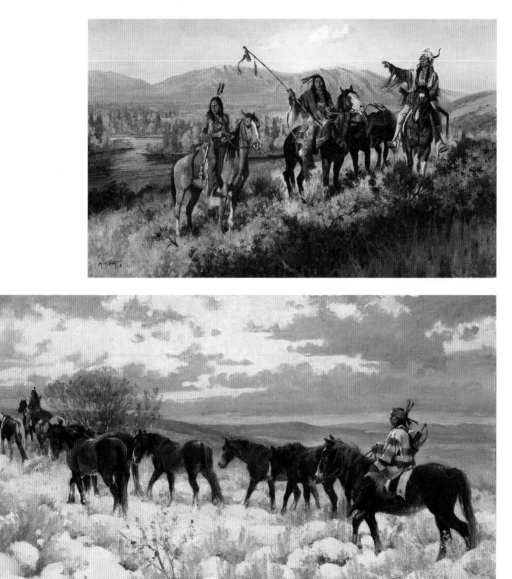

Scouting for the Winter Camp.
29" × 50".

Winter's Grip. Oil. 19" × 32".

M. C. POULSEN

CODY, WYOMING

In my heart, I have been an artist my entire life. I was raised on a cattle and outfitting ranch near Cody, Wyoming. My love for the West became my palette for working and painting the people I have met and the scenes I have experienced over the years.

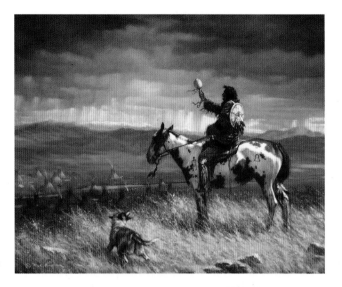

Rainmaker. 24" × 36". 1989.
Photo courtesy of Ron Maier Photography

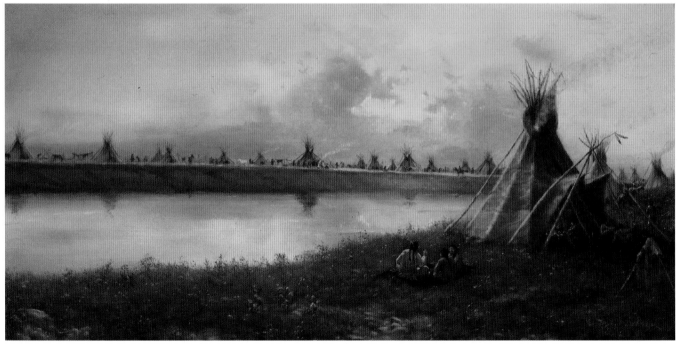

Story of Where the Sun Goes. Oil on board. 18" × 30". 1998. *Photo courtesy of Ron Maier Photography*

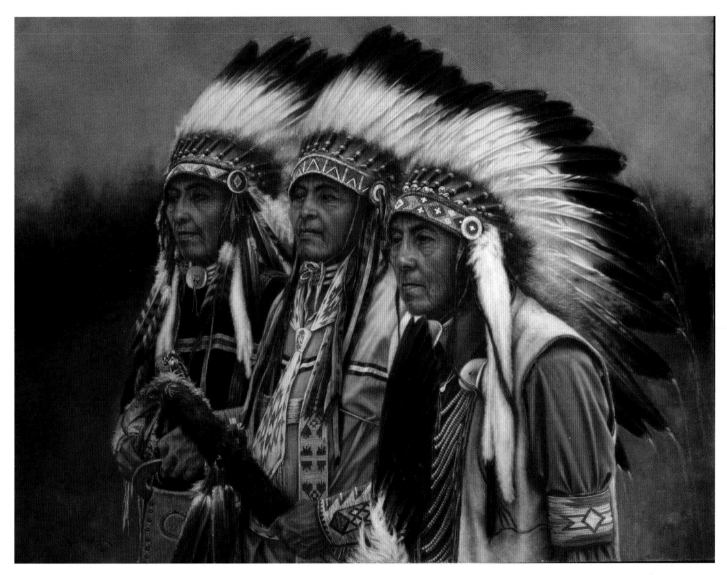

Ancient Echoes. Oil on board. 36" × 40". 2005. *Photo courtesy of Ron Maier Photography*

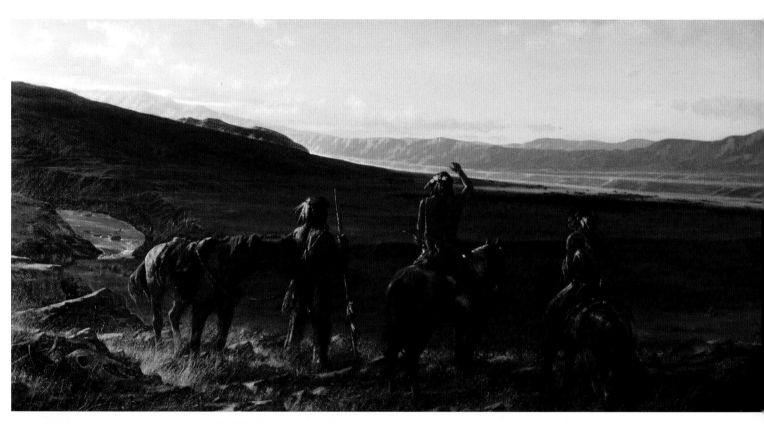

Before White Man. Oil on canvas. 39.5" × 155.75". 1995. *Courtesy of Booth Museum*

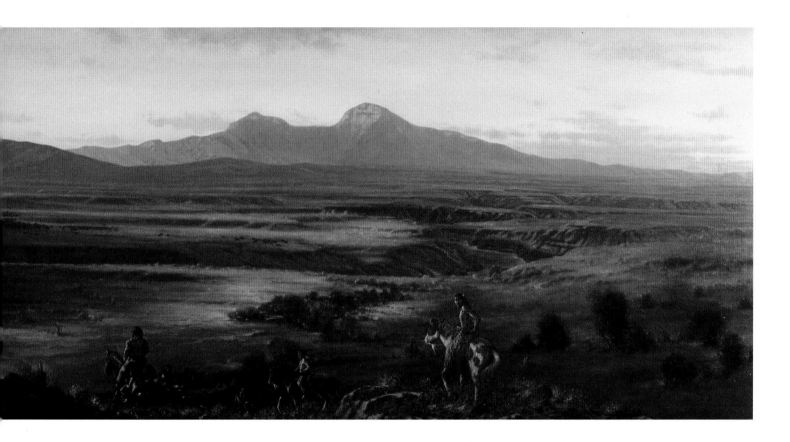

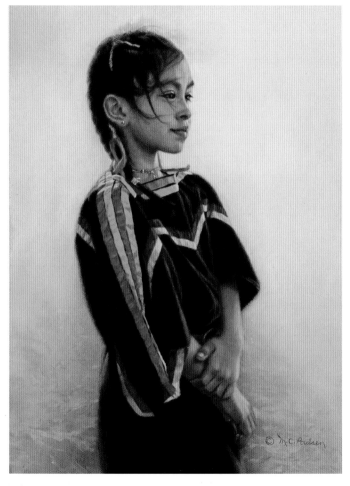

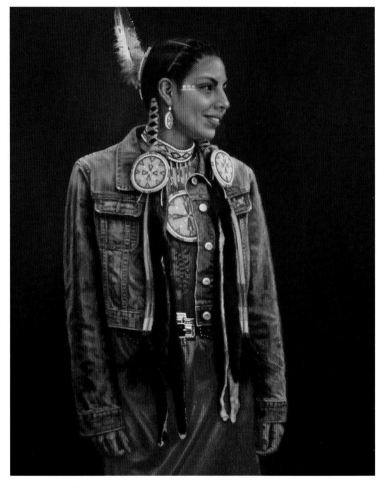

Whispering Breezes. Oil on board. 20" × 16". 2014. *Photo courtesy of Ron Maier Photography*

Denim and Silk. Oil on board. 24" × 18". 2012. *Photo courtesy of Ron Maier Photography*

R. S. RIDDICK

TUCSON, ARIZONA

I am a dedicated student of art history. My personal style finds fulfillment in the rich and diverse subject matter in the great American West. The Creative Spirit journey is like individual streams of water feeding a large river and filling a greater lake; each drop of history can sharpen our skill and nurture our talent along the way.

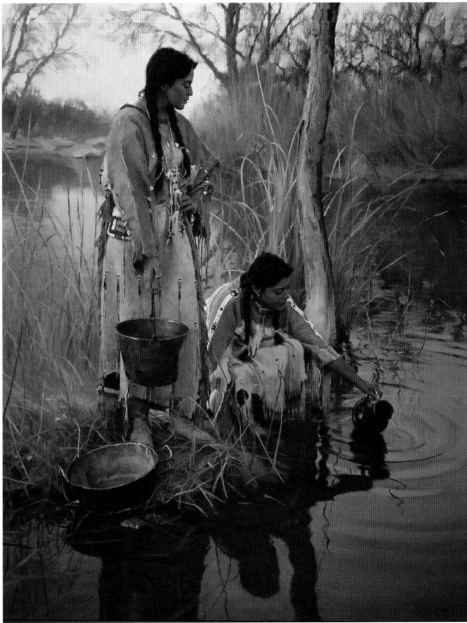

Lakota Water Maidens. Oil. 60" × 48". 2000.
Photo courtesy of Mary Findysz Photographic Works

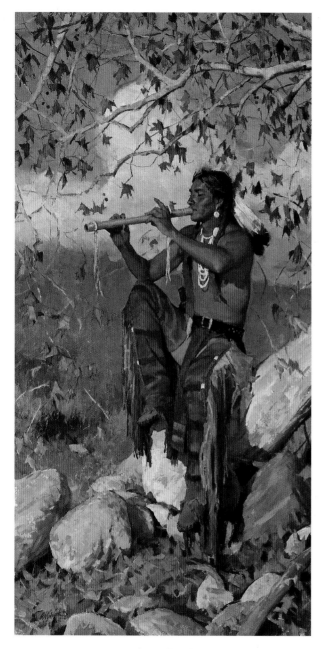

Leaves That Listen. Gouache. 45" × 23". 2012.

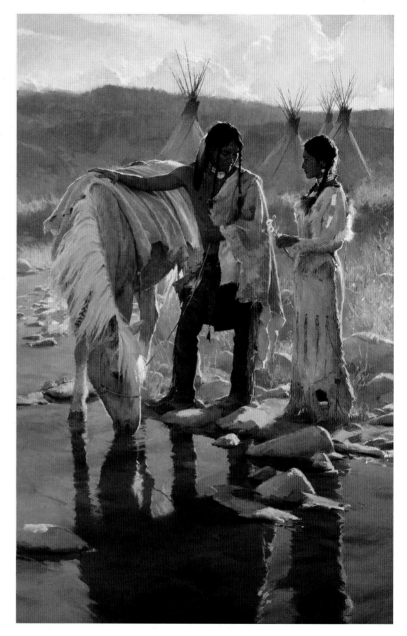

Lakota Warrior's Farewell. Oil. 72" × 46". 2005. *Photo courtesy of Mary Findysz Photographic Works*

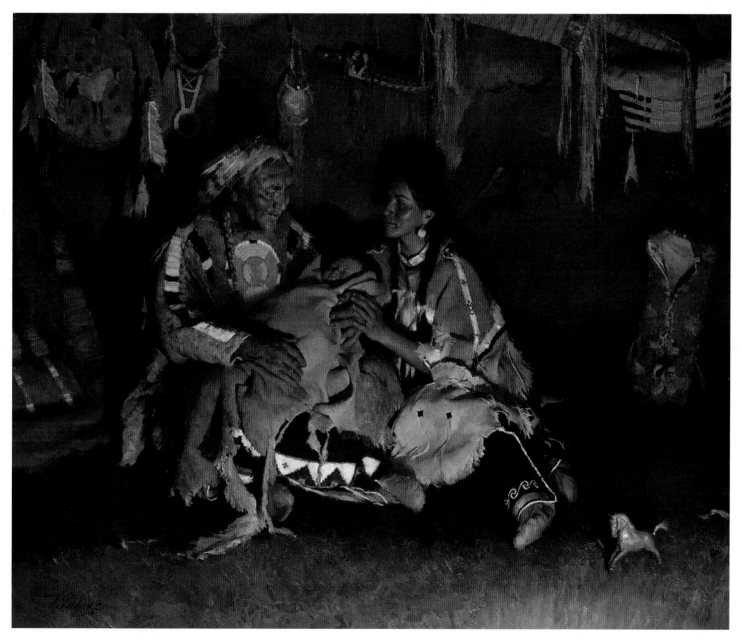

First Spring, Last Summer. Oil. 59" × 69". 2014.

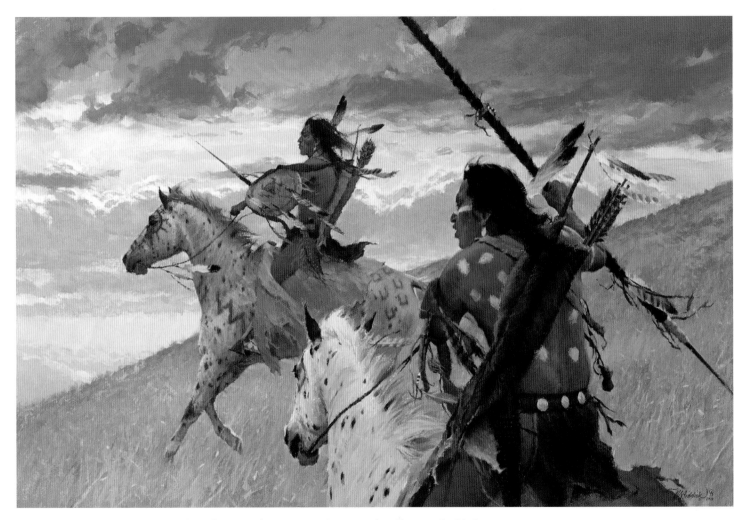

Prairie Storm Coming. Gouache. 25" × 38". 2002. *Photo courtesy of Mary Findysz Photographic Works*

ROSETA SANTIAGO

SANTA FE, NEW MEXICO

I grew up in Washington, DC, in a multi-cultural environment: raised by a Polish/Russian mother and a Filipino/Spanish father who was a steward in the US Navy and was Harry Truman's chef on the USS *Missouri* and in the White House. My life has always been filled with mystery and the exotic.

When I decided to fulfill my dream of becoming a fine-art painter, the mysterious West and its living history of medicine men, ceremonies, and regalia called me. I took a leap of faith, moved to Santa Fe, taught myself to paint in oils, and now try to capture the beauty of the indigenous people here and discover the meaning of their lives and mine.

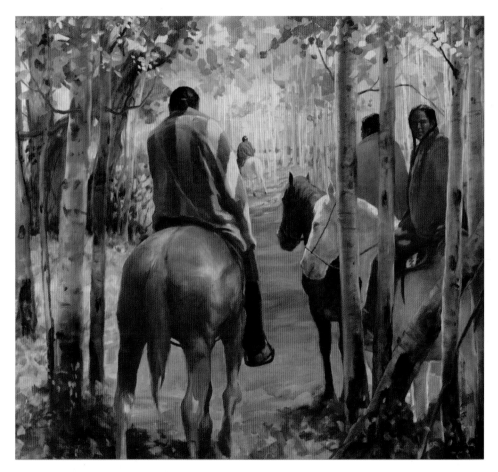

Quiet Journey Into the Aspen. Oil on canvas. 45.5" × 49.5". 2015. *Courtesy of Blue Rain Gallery*

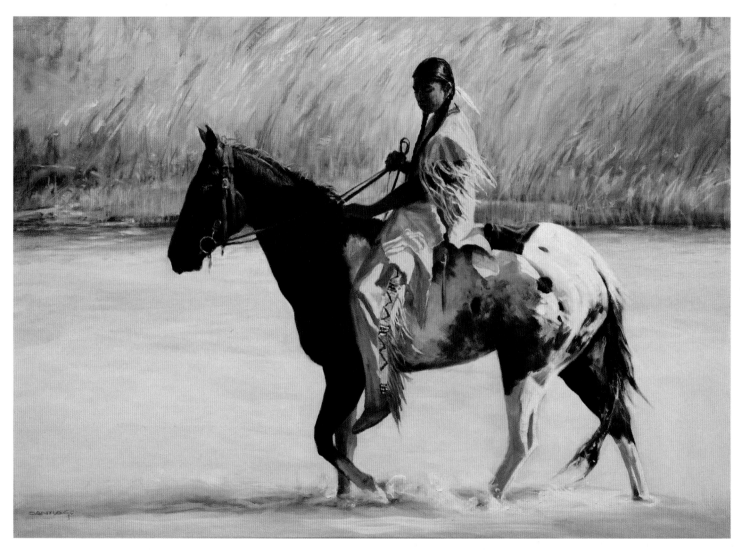

A Young Man's Fancy. Oil on linen. 34" × 48.5." 2014. *James Hart Photography*

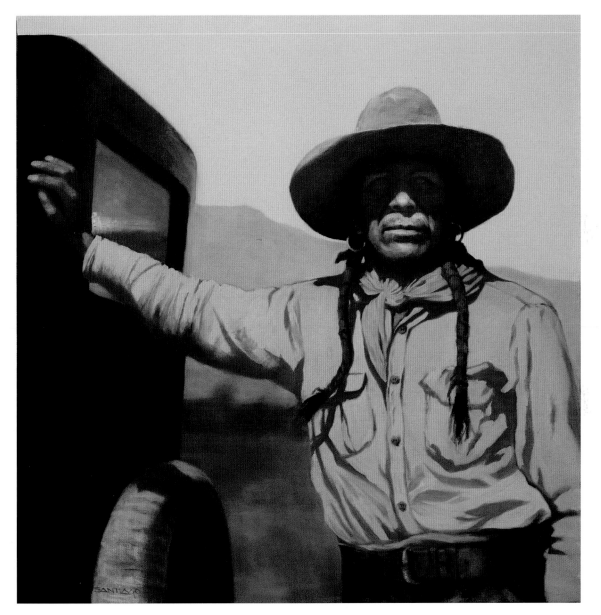

Waitin' On Juanito. Oil On Canvas. 36" × 36". 2016. *James Hart Photography*

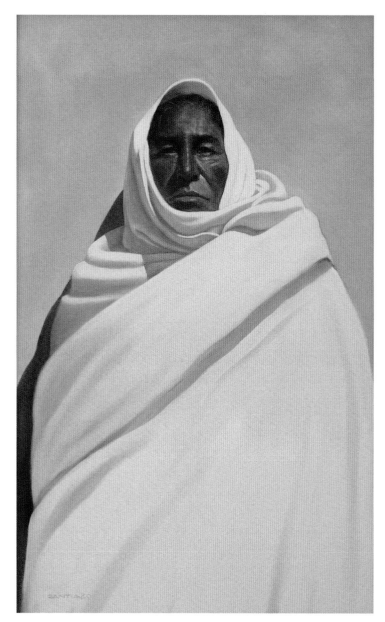

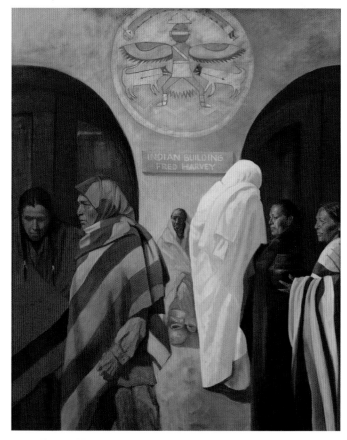

The Indian Building. Oil on canvas. 72" × 58". 2014.
James Hart Photography

The Past is Before Us. 45" × 28". 2016. *James Hart Photography*

H. DAVID WRIGHT

GALLATIN, TENNESSEE

The history of our country has always fascinated me. I paint people in the historical environment, creating an atmosphere, rather than detailing the event itself. In this way, you can see and understand—even feel—that essential moment in history that shows our heroes as they were: explorers, hunters, trappers, settlers, soldiers, and Indians.

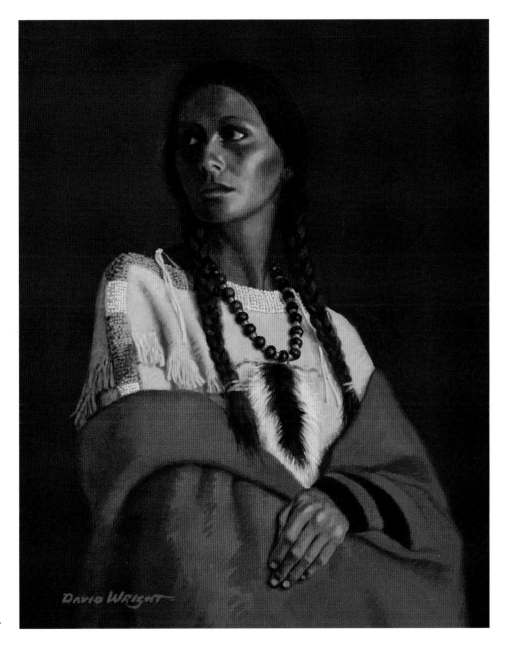

Yesterday's Thoughts. Oil on panel. 10" × 8". 2015.

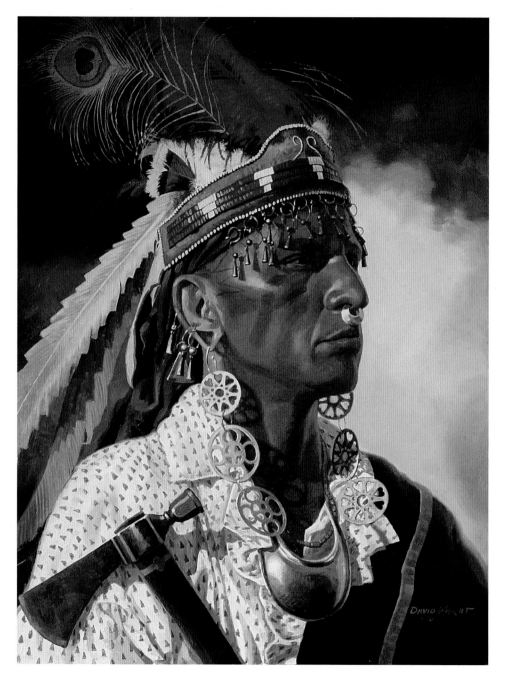

Shawnee. Oil on panel. 12" × 9". 2004.

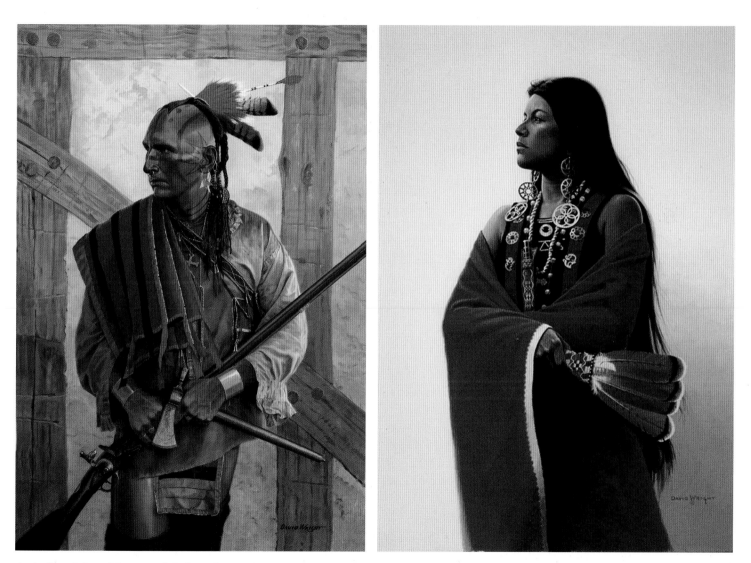

At the French Post. Oil on panel. 35" × 23". 2008.

Ahnawake. Acrylic on panel. 28" × 20". 1990.

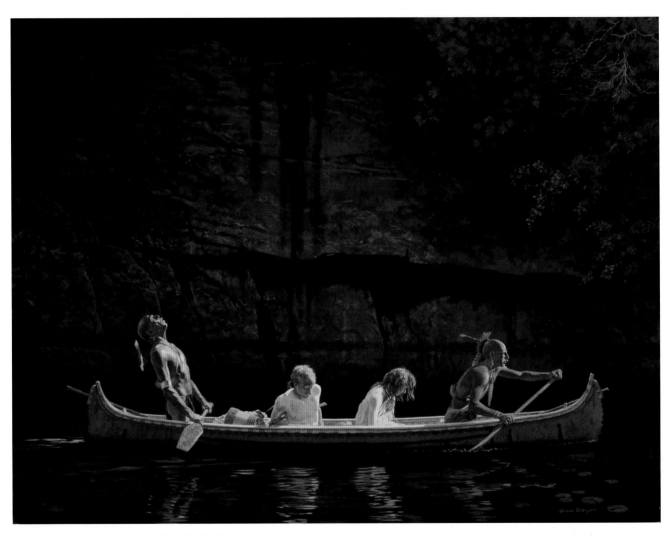

The Captives. Oil on canvas. 36" × 48". 2008.

RESOURCES

ARTISTS' WEBSITES AND CONTACT INFORMATION

Tony Abeyta
arttone@yahoo.com

William Acheff
info@acheffstudio.com

Roy Andersen
www.insightgallery.com

James Ayers
www.jamesayers.com

Shonto Begay
www.facebook.com/Shonto-Be-gay-6074182987/

Harley Brown
www.settlerswest.com

Blair Buswell
www.blairbuswell.com

George Carlson
www.georgecarlsonart.com

John Coleman
www.colemanstudios.com

Allen Eckman
www.eckmanfineart.com

Patty Eckman
www.eckmanfineart.com

Ethelinda
www.ethelinda.net

John Fawcett
www.johnfawcettstudio.com

Fred Fellows
www.fellowsstudios.com

Charles Fritz
www.charlesfritz.com

Martin Grelle
www.ackermansfineart.com

Robert Griffing
www.paramountpress.com

Logan Maxwell Hagege
www.loganhagege.com

Doug Hyde
info@broadmoorgalleries.com
www.nedramatteuccigalleries.com

Oreland Joe
www.orelandjoe.com

Z. S. Liang
www.liangstudio.com

Jeremy Lipking
www.lipking.com

David Mann
www.legacygallery.com/portfolio/david-mann/

Allan Mardon
www.allanmardon.com

Krystii Melaine
www.krystiimelaine.com

John Moyers
www.johnmoyersart.com

John Nieto
www.nietofineart.com

Jim Norton
www.legacygallery.com/portfolio/jim-norton-ca/

M. C. Poulsen
www.mcpoulsen.com

R. S. Riddick
mailto:rsriddickstudio@outlook.com
pacifichp@aol.com

Roseta Santiago
www.rosetasantiago.com

H. David Wright
www.davidwright.com

GALLERIES AND EXHIBITION SPACES

Altamira Fine Art, Jackson, Wyoming
Arcadia Contemporary, Culver City, California
Arkansas Gallery, Jackson Hole, Wyoming
Astoria Fine Art, Jackson, Wyoming
Beartooth Gallery, Red Lodge, Montana
Berlin Gallery, Phoenix, Arizona
Blue Rain Gallery, Sante Fe, New Mexico
Breckenridge Gallery, Breckenridge, Colorado
Broadmoor Galleries, Colorado Springs, Colorado
Bronze Coast Gallery, Cannon Beach, Oregon
Claggett Rey Gallery, Vail, Colorado
Davis & Blevins Gallery, Saint Jo, Texas
Evergreen Fine Art, Evergreen, Colorado
Gerald Peters Gallery, Santa Fe, New Mexico,
 and New York, New York
InSight Gallery, Fredericksburg, Texas
J. N. Bartfield Galleries, New York, New York
Keating Fine Art of Basalt, Colorado
Legacy Gallery, Scottsdale, Arizona; Bozeman, Montana;
 and Jackson, Wyoming
Legends and Legacies, Spearfish, South Dakota
Lord Nelson's Gallery, Gettysburg, Pennsylvania
Lunds Fine Art Gallery, Park City, Utah
Manitou Galleries, Santa Fe, New Mexico

Mark Sublette Medicine Man Gallery, Santa Fe, New Mexico,
 and Tucson, Arizona
Maxwell Alexander Gallery, Los Angeles, California
Michael's on Main, Cañon City, Colorado
Modern West, Salt Lake City, Utah
Mountain Trails Fine Art, Sedona, Arizona; Santa Fe, New
 Mexico; Park City, Utah; and Aspen, Colorado
Nedra Matteucci Galleries, Santa Fe, New Mexico
The Owings Gallery, Sante Fe, New Mexico
Painters Chair Fine Art, Coeur d'Alene, Idaho
Plainsmen Gallery, Dunedin, Florida
Saks Galleries, Denver, Colorado
Settlers West Galleries, Tucson, Arizona
The Signature Gallery, Santa Fe, New Mexico
Simon Gallery of Fine Art, Tucson, Arizona
Trailside Galleries, Scottsdale, Arizona, and Jackson, Wyoming
Valley Bronze Gallery, Joseph, Oregon
Ventana Fine Art, Santa Fe, New Mexico
West of the Moon Gallery, Flagstaff, Arizona
Whiteside Galleries, Hilton Head, South Carolina
Whitney Gallery of Western Art, Cody, Wyoming
Wilcox Gallery, Jackson, Wyoming
Wildhorse Gallery, Steamboat Springs, Colorado
Wood River Fine Arts, Ketchum, Idaho

MUSEUMS

Albuquerque Museum, Albuquerque, New Mexico

Amon Carter Museum of Western Art, Fort Worth, Texas

Ancient Ozark History Museum, Ridgedale, Missouri

Autry Museum of the American West, Los Angeles, California

Blanton Museum of Art at the University of Texas, Austin, Texas

Bone Creek Museum of Agrarian Art, David City, Nebraska

Booth Western Art Museum, Cartersville, Georgia

Bradford Brinton Museum, Big Horn, Wyoming

Briscoe Western Art Museum, San Antonio, Texas

Buffalo Bill Museum Center of the West, Cody, Wyoming

Cheyenne Old West Museum, Cheyenne, Wyoming

Clymer Museum of Art, Ellensburg, Washington

C. M. Russell Museum, Great Falls, Montana

Colorado Springs Fine Arts Center, Colorado Springs, Colorado

Cumberland Gap National Historical Park, Kentucky, Tennessee, and Virginia

Denver Art Museum, Denver, Colorado

Desert Caballeros, Wickenburg, Arizona

Eiteljorg Museum of American Indians and Western Art, Indianapolis, Indiana

Ella Sharp Museum of Art & History, Jackson, Michigan

Fenimore Art Museum, Cooperstown, New York

Gilcrease Museum, Tulsa, Oklahoma

Glenbow Museum, Calgary, Alberta, Canada

Green-Wood Cemetery, Brooklyn, New York

Heard Museum, Phoenix, Arizona

Heinz History Museum, Pittsburgh, Pennsylvania

Institute of American Indian Art Museum, Santa Fe, New Mexico

James Museum of Western and Wildlife Art/ Raymond James Financial Collection, St. Petersburg, Florida

Joslyn Art Museum. Omaha, Nebraska

Lakeview Museum of Arts & Sciences: The Southwestern Art Collection of Charles & Jeanette Gilchrist White, Peoria, Illinois

Leigh Yawkey Woodson Art Museum, Wausau, Wisconsin

Lewis & Clark Interpretive Center, Fort Mandan, Washburn, North Dakota

Loveland Museum, Loveland, Colorado

Marine Corps Museum, Washington, DC

McNider Art Museum, Mason City, Iowa

Midwest Museum of American Art, Elkhart, Illinois

Montana Historical Society, Helena, Montana

Montclair Art Museum, Montclair, New Jersey

Museum of Contemporary Art, Hot Springs, Arkansas

Museum of Fine Arts, Boston, Massachusetts

Museum of Indian Arts & Culture, Santa Fe, New Mexico

Museum of the Plains Indian, Browning, Montana

Museum of Western Art, Kerrville, Texas

National Cowboy and Western Heritage Museum, Oklahoma City, Oklahoma

National Museum of the American Indian, Smithsonian Institution, Washington, DC

National Museum of Wildlife Art, Jackson Hole, Wyoming

National Portrait Gallery, Smithsonian Institution, Washington, DC

Neville Public Museum, Green Bay, Wisconsin

New Mexico Museum of Fine Arts, Santa Fe, New Mexico

Owensboro Museum of Art, Owensboro, Kentucky

Palm Springs Art Museum, Palm Springs, California
Pasadena Museum of History, Pasadena, California
Pearce Museum, Corsicana, Texas
Phippen Museum, Prescott, Arizona
Phoenix Art Museum, Phoenix, Arizona
Rahr-West Museum, Manitowoc, Wisconsin
Rockwell Museum, Corning, New York
Stark Museum, Orange, Texas
Steamboat Art Museum, Steamboat Springs, Colorado
Tacoma Art Museum, Tacoma, Washington
Tucson Museum of Art, Tucson, Arizona
Virginia Museum of Animal Art, Charlottesville, Virginia
Western Spirit, Scottsdale's Museum of the West,
 Scottsdale, Arizona
Westmoreland Museum of American Art, Greensburg,
 Pennsylvania
Woolaroc Museum, Bartlesville, Oklahoma